Dear Dick Smith,
I Hope you enjoy my book.

IMAGES
of America
FORT DE SOTO PARK

D1294595

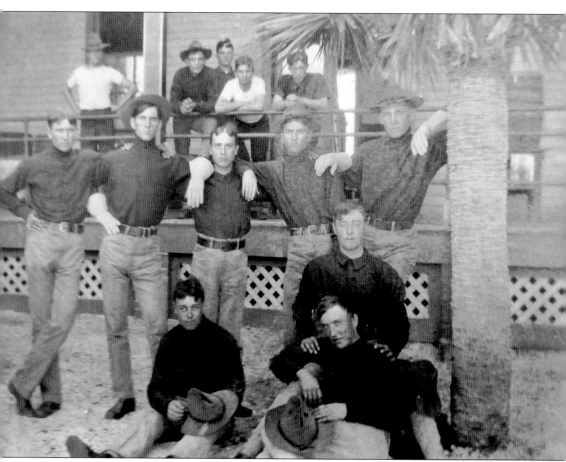

In 1905, fifty-eight years before the cover photograph was taken, these 13 soldiers posed in front of the barracks presenting their own special brand of welcome to Fort De Soto. (Courtesy of the Fort De Soto Archives and Phil Schiro.)

IMAGES
of America

FORT DE SOTO PARK

Terry Nelson

ARCADIA
PUBLISHING

Copyright © 2021 by Terry Nelson
ISBN 978-1-4671-0752-5

Published by Arcadia Publishing
Charleston, South Carolina

Printed in the United States of America

Library of Congress Control Number: 2021940979

For all general information, please contact Arcadia Publishing:
Telephone 843-853-2070
Fax 843-853-0044
E-mail sales@arcadiapublishing.com
For customer service and orders:
Toll-Free 1-888-313-2665

Visit us on the Internet at www.arcadiapublishing.com

This book is dedicated to my editor in chief, research assistant, and loving wife, Barbara, without whom it would never have been written! Also to my sons, Chris and Jeff, who are always an inspiration for me.

CONTENTS

ACKNOWLEDGMENTS

There are many people without whose help this book could not have been put together. Margaret Santangelo and Rhonda Omslaer of the Friends of Fort De Soto, park supervisor David Harshbarger, and park gift shop manager Laura Burrows were all very obliging in helping to get this project started when it was still just the kernel of an idea. A big debt of gratitude is owed to Patricia Landon, museum specialist at the Pinellas County Heritage Village Archives and Library, and the Pinellas County Historical Society for offering hundreds of fascinating photographs that ended up providing nearly one third of the total images herein. The Fort De Soto County Park historic guide, published by Pinellas County Parks and Recreation and available online, provided much of the information regarding the park's historic buildings. Frank B. Sarles's *Historic Sites Report on Fort De Soto Park* also added many key details.

Alan Shellhorn, Pinellas County employee and retired US Army officer, furnished many unique images not available elsewhere. Sally Yoder and Catherine Wilkins of the Gulf Beaches Historical Museum, on Pass-a-Grille, helped to facilitate the inclusion of several photographs, as did Andy Huse at the University of South Florida. Toni and Pat Walsh, my sister and brother-in-law, of Tierra Verde did invaluable local research that was most useful. Tim Nelson, my brother, of Port St. Joe performed outstanding photographic surgery on some images that initially were a bit rough.

Dennis Whelan's fascinating book *The Pinellas Puzzle: A History of Tierra Verde, Mullet Key, and the New Uplands of the Lower Boca Ciega Bay* supplied much useful background information, as did fortdesoto.com, an unofficial park website. Mike Miller, the pride of Owosso, Michigan, but now of Largo, helped vet hundreds of Fort De Soto archives photographs. My neighbor Lt. Col. Scott F. Hume (US Army retired) gave many interesting insights into fort life. Thanks also to my hardworking Arcadia Publishing editor, Angel Prohaska, as well as Arcadia's Katelyn Jenkins and Mike Kinsella for green lighting this project.

Finally, a huge thank you goes out to Phil Schiro, Fort De Soto Park tour guide, member of the Friends of Fort De Soto, and US Navy veteran. Phil's tireless efforts in digging up and vetting photographs, imaging those photographs, and providing fascinating background information about those images were invaluable in the completion of this book.

Many images in this volume appear courtesy of the Pinellas County Heritage Village Archives and Library (HV), the Library of Congress (LC), the University of South Florida (USF), Florida Memory (FM), the US Geological Survey (USGS), the Gulf Beaches Historical Museum (GBM), and the Fort De Soto Park archives (FDS). All uncredited images are courtesy of the author.

INTRODUCTION

Fort De Soto Park's beginnings date to 1849, ninety-nine years before the park was formally opened. In that year, Robert E. Lee recommended that Mullet Key, the island the park is centered around, be set aside as a military reserve along with nearby Egmont Key. The Army accepted his proposal, setting in motion a series of events that led to the creation of a world-class park that attracts millions of visitors each year. The antecedents of these events, however, stretch back hundreds of years before Lee's visit.

Archaeological evidence indicates that local groups of the Tocobaga, a Native American tribe, had long inhabited the territory surrounding Tampa Bay. By 1000 AD, they were active in what is now Pinellas Point in South St. Petersburg and Cabbage Key, both just a short canoe journey from Mullet Key. Known as mound builders, the Tocobaga created several mounds still in existence throughout the area.

Life for the Tocobaga changed forever with the arrival of the Spanish in the early 1500s.

In 1539, Hernando de Soto made landfall in the area, possibly in what is now Bradenton. His expedition soon headed off for its several-year journey upon which he became the first European to see the Mississippi River. Back on Florida's Gulf Coast, however, his company left behind a very interesting legend.

Fast forwarding to the early 1800s, Capt. William Bunce, the first European to permanently settle on the islands of lower Boca Ciega Bay, took advantage of the widespread Spanish settlement in places like Cuba by setting up the business of selling them fish. Sadly, federal troops twice destroyed his business for allegedly being too cozy with the Seminoles. On the positive side, there is a body of water next to Mullet Key named after him.

Of course, as is well known, the heavy Spanish influence in the islands south of Florida led to the Spanish-American War in 1898. Enter Fort De Soto, which, along with Fort Dade on nearby Egmont Key, was ordered to be built on the places Robert E. Lee had recommended reserving for defense 50 years earlier. Although that war ended just a few months after it began, the decision was made to finish Fort Dade and Fort De Soto. The pride and joy of Fort De Soto's fully intact mortar battery are the four (out of the original eight) beautifully preserved 12-inch mortars, admired by adults and climbed upon by children.

On May 11, 1963, a dream of Pinellas County officials finally came true with the gala grand opening of the new Fort De Soto Park. In reality, Fort De Soto Park opened in 1948 with a modest ceremony. But the dream had long been of a spectacular, modern park with facilities designed to fit the needs and interests of anyone who visited. Some of the early visions were perhaps a bit too spectacular, but in the end, a perfect balance was met. Fort De Soto Park's 2.7 million visitors each year prove that it never disappoints.

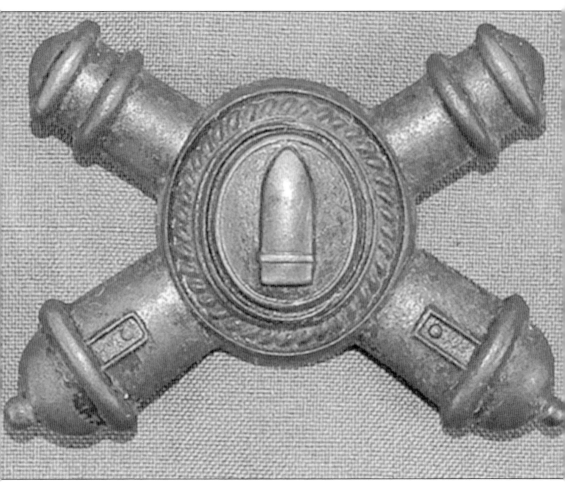

Pictured here is an officer's lapel pin featuring the insignia of the US Army Coast Artillery Corps (CAC). The CAC was responsible for coastal and harbor defense of the United States between 1901 and 1950. Pres. Chester A. Arthur initially spoke of the need for fixed coastal defenses in 1882. The patron of the CAC was St. Barbara, patron saint of those who work with explosives such as armorers, artillerymen, and military engineers due to her story's connection with lightning. (Courtesy of Griffin Militaria.)

One

THE FORT

In 1849, Robert E. Lee, then a brevet (a rank bestowed as an honor for outstanding service) colonel was sent by the US Army to Tampa Bay to evaluate coastal defense needs. Among his findings were that Mullet and Egmont Keys, due to their positions overlooking the Gulf of Mexico's entrance into Tampa Bay, could be of significant use in defending the bay. Based on Lee's report, the US government ordered that the two islands be reserved for military use. Lee's recommendations turned out to be prescient when the USS *Maine* exploded and sank in Havana Harbor on February 15, 1898. On April 25, 1898, the United States declared war on Spain. By May, a large Spanish fleet arrived in Santiago, Cuba, just a few days sail away from Tampa Bay.

The construction of Fort De Soto on Mullet Key was underway by November 1898. The construction of Fort Dade, on nearby Egmont Key, began about that time as well. Although the war ended in December 1898 with a decisive American victory, the decision was made to finish both forts. Fort De Soto became operational in May 1900 when a detachment of Company A, 1st Artillery (renamed 1st Company, Coast Artillery after a reorganization) was garrisoned there. All buildings were completed by 1906 at a cost of $155,000—about $5 million today. Fort Dade, a much more complex facility, nonetheless was also completed in 1906.

In the 1920s and 1930s, storms damaged or destroyed many of Fort De Soto's buildings, and in 1939, the remaining structures were dismantled and sold as salvage. In the 1990s, original fort building foundations, which had been buried by sand, were located and reconstructed by park staff, Eagle Scouts, and volunteers using 1911 blueprints (the sidewalks and brick roads are original). This was a major undertaking and a true gift to those who love history and Fort De Soto Park.

This chapter offers a guide to original fort armaments and structures, or remains of structures, that still exist. The present-day visitor to Fort De Soto can walk through the area where many buildings once stood and imagine life on the post.

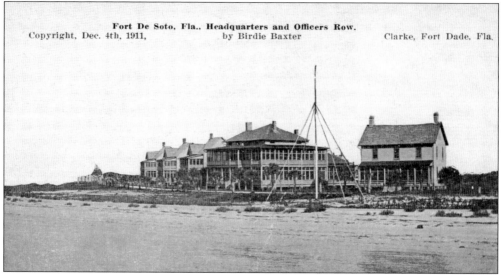

Officers Row is to the left of the flagpole. The largest structure is the commander's quarters, followed by three buildings for junior officers. To the right of the flagpole is the administration building. (Courtesy of Alan Shellhorn.)

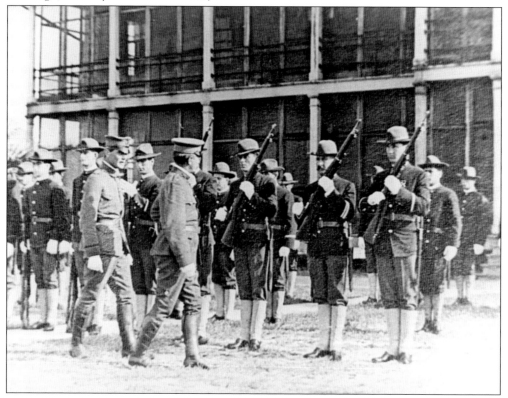

Two senior officers conduct what might well be a payday inspection in front of the Fort De Soto barracks. Although the officers are in field uniforms, the enlisted men are in dress uniforms topped off with campaign hats. Whatever the reason for this inspection, for an added incentive, there's a good chance that whoever comes off as the best of the group will get the day off! (Courtesy of HV.)

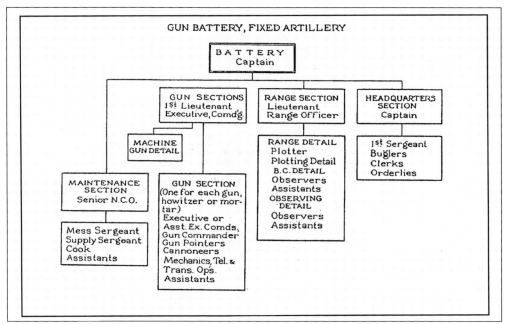

This organizational chart, from a 1939 ROTC training manual, shows what the division of duties was at coastal batteries such as Fort De Soto. The manual explains that coastal artillery companies were units of men, with batteries defined as fixed gun emplacements. Each company was authorized 109 enlisted men, including noncommissioned officers. Every battery was given an individual name by the US Department of War so as to distinguish it from other batteries. (Courtesy of the US Army.)

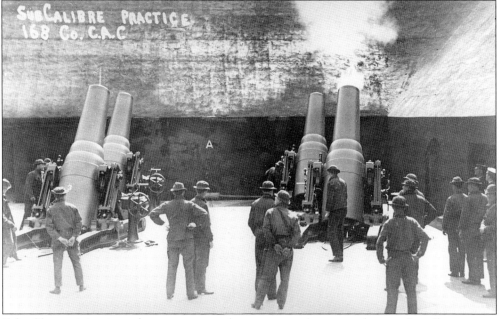

Subcaliber training is used to save wear and expense on a larger gun by use of smaller weapons with similar ballistic characteristics. Modifications could include a tube inserted into the larger weapon's barrel or an externally attached barrel mounted to the weapon. (Courtesy of HV.)

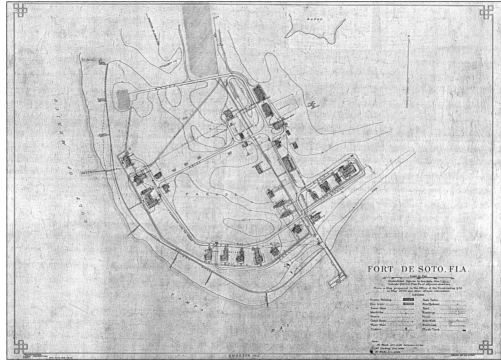

The 1911 diagram above of Fort De Soto was taken from a map made in May 1909 by the Army's Office of the Constructing Quartermaster. Below is a fort diagram numbered for use with a self-guided tour. It was created after the fort's restoration project. The places seen on the map are as follows: 1) ordnance storehouse; 2) stables; 3) wagon shed; 4) oil house; 5) water tank; 6) pump house; 7) searchlight shelter; 8) engineering building; 9) artesian wells; 10) quartermaster storehouse; 11) bakery; 12) civilian quarters; 13) sewer system flush tanks; 14) lavatory; 15) fire apparatus house; 16) post exchange; 17) mess hall and kitchen; 18) barracks; 19) observation tower/fire control building; 20) single officer's quarters; 21) commander's quarters; 22) administration building; 23) guardhouse; 24) quartermaster wharf; 25) mine storage; 26) noncommissioned officers' quarters; 27) double noncommissioned officers' quarters; 28) hospital steward quarters; 29) hospital; 30) quarantine wharf (located off this map); 31) storehouse, quartermaster, and subsistence building; and 32) workshops. (Above, courtesy of HV; below, courtesy of the Pinellas County Parks Department.)

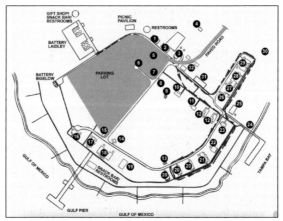

Beyond the dirt road (with the signs on it) going horizontally across this image lie the foundations of one of the single officer's quarters (No. 20 on the fort tour). Farther back are the remains of the fire control tower (the tall slender tower), which was used to coordinate the firing of the mortars, and a flush tank, on the extreme right. The signs explain various historical remains nearby.

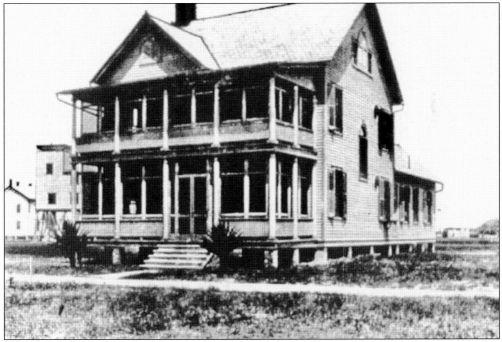

One of the three single officer's quarters (meaning housing for one officer, not marital status) is pictured here. Note the fire control tower on the left with the barracks behind it. Each one of these was around 3,000 square feet and cost $5,529 ($177,000 today). (Courtesy of USF.)

This photograph shows the foundations of the other two single officer's quarters, which are also partially visible in the image on top of page 13 in front of the road.

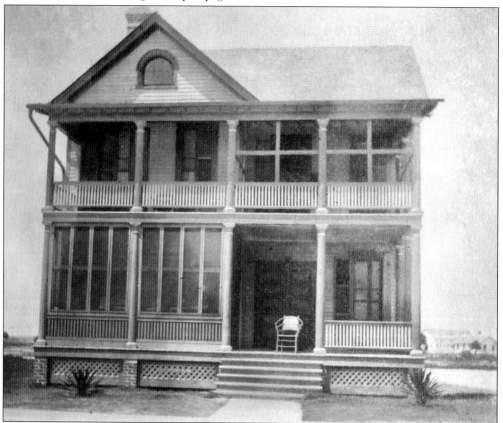

The chair on the front porch of this single officer's house looks ready for someone to use for a relaxing view of a Gulf of Mexico sunset. (Courtesy of HV.)

The wide expanse of these foundations shows that the commander's quarters was one of the largest buildings on the base (No. 21 on the tour). Its 4,770-square-foot area included a reception hall, parlor, dining room, and study. (Photograph by Phil Schiro.)

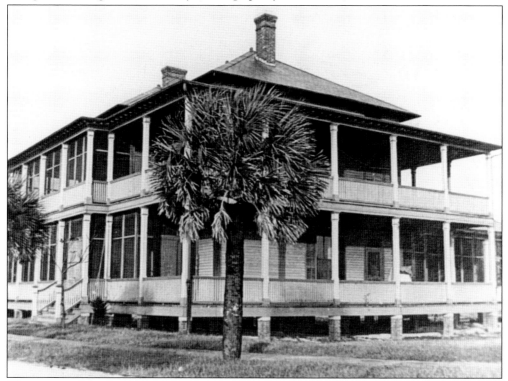

The commander's quarters cost $10,000 ($320,000 today) to build. It was wired for electricity, but since there was no base generator available, oil lamps were used for lighting. (Courtesy of HV.)

The foundation seen at left is for the administration building (No. 22 on the tour). Slightly visible in the distance to the right is the Sunshine Skyway Bridge. The foundation to the right is that of the commander's quarters.

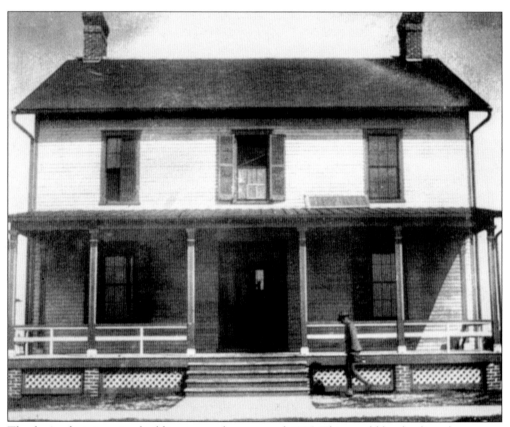

The fort's administration building is seen here around 1905. This would be the first place a new enlistee would check in for processing. This structure had 2,248 square feet of floor space and cost $4,106 ($131,000 today). (Courtesy of the National Archives.)

The foundation of the guardhouse (No. 23 on the tour) is clearly visible along with the original sidewalk in front. This was headquarters for the soldiers who guarded the post, and it also contained space to house detainees.

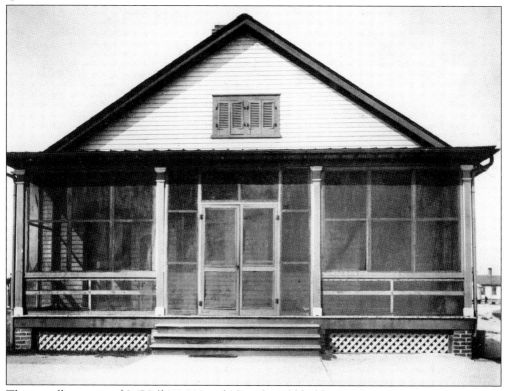

The guardhouse cost $3,476 ($111,000 today) and could hold up to five prisoners in 957 square feet of space. (Courtesy of HV.)

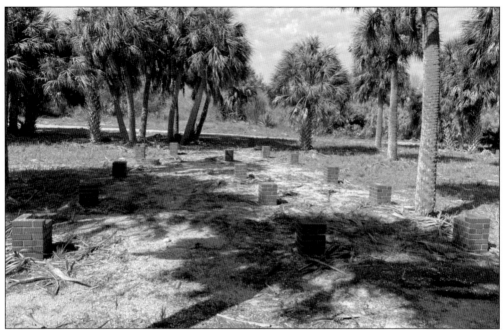

No. 26 on the tour is the foundation for a noncommissioned officers' (NCOs) quarters. NCOs are enlisted service members in leadership positions.

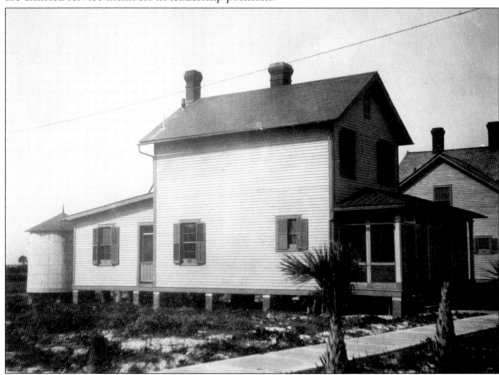

The NCO quarters pictured here cost $3,658 ($117,000 today) and had 1,062 square feet of floor space. The cistern in the back collected water for drinking. All residential buildings had similar cisterns. (Courtesy of HV.)

Palmetto and cabbage palms crowd the foundation of the double NCO quarters (No. 27 on the tour).

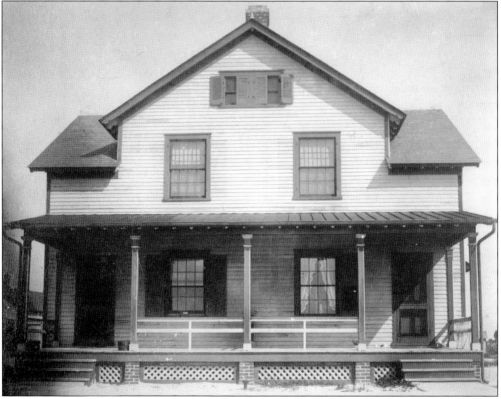

Two families could be accommodated in these double NCO quarters. This building encompassed 2,022 square feet of space, and its construction costs totaled $4,583 ($117,000 today). Part of this building was also used as a post office. (Courtesy of HV.)

The local palms are also sharing space with the hospital steward's quarters foundation, which is No. 28 on the tour. The hospital steward was a noncommissioned officer whose duties included making up prescriptions, administering medicines, and generally supervising patients under the instructions of an Army medical officer.

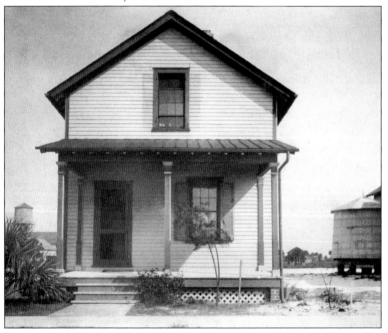

On the left, behind the hospital steward's residence, is the base's water tower. To the right of the building is a cistern for the hospital. The steward's quarters had 1,000 square feet on its two floors and cost $2,653 ($85,000 today) to build. (Courtesy of HV.)

The hospital, No. 29 on the tour, is the only building on the base with a concrete basement. Construction costs were $9,726 ($311,000 today).

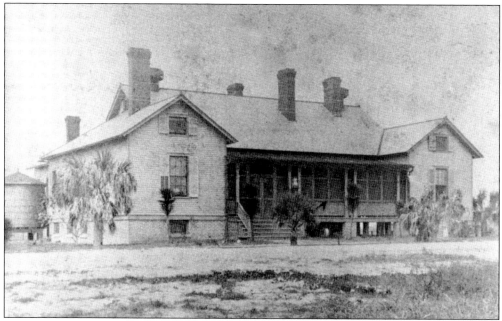

The hospital's 2,628 square feet of space allowed for 10 beds. Amenities listed include four wash sinks (for washing dishes or instruments), three wash basins (for washing one's self), one bathtub, two toilets, and a urinal. Note the brick walls on the foundation at left, where the concrete basement is located. This image is from around 1910. (Courtesy of HV.)

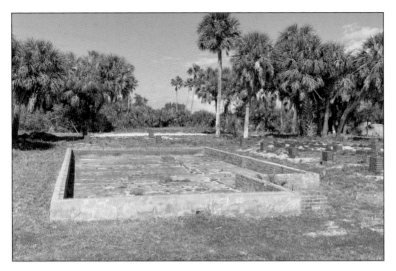

The subterranean concrete hospital floor shown here was completely covered with sand until its excavation and restoration took place in the 1990s. This flooring arrangement helped to keep the room cool for perishable supplies, and it could also be used as a morgue.

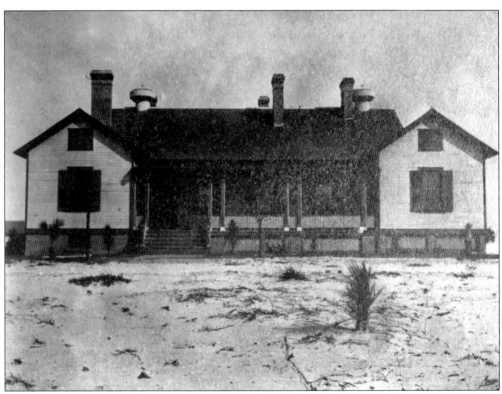

The hospital, pictured here in 1905 not long after completion, is surrounded by a very uninviting landscape. Eventually, landscaping was ordered to remedy the starkness of the grounds, as can be seen in the previous hospital image. The cool room is on the left. Again, note the brick walls on the foundation at left in comparison to the lattice covering the crawl space on the rest of the building. (Courtesy of HV.)

No. 12 on the tour is the civilian quarters. There were two identical units for the housing of civilian employees.

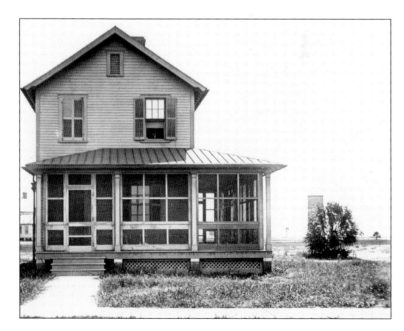

The two civilian quarters cost $3,765 each ($120,000 today), and each contained 1,062 square feet of floor area. In the background to the right of the house can be seen the fire control tower. (Courtesy of HV.)

The hearth is still very much intact for No. 11 on the tour, the bakery. It had a floor area of 619 square feet and cost $1,557 ($50,000 today) to build.

The cozy look of the bakery, with the shrubs planted around the entrance, likely belies the difficult job of working during a Florida summer in an already very hot building! (Courtesy of HV.)

No. 31 on the tour is the storehouse, quartermaster, and subsistence building. It was near the base wharf and was centrally located to most key service and infrastructure buildings. In front lies the original brick road, stretching toward the wharf.

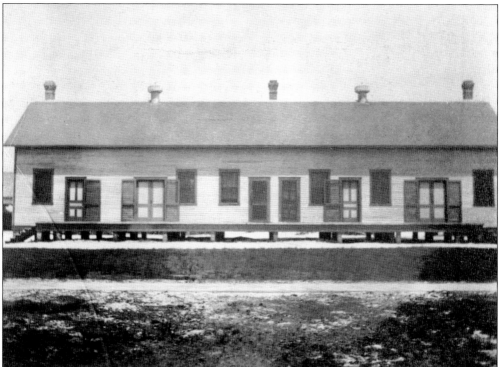

The storehouse had 4,065 square feet of floor area and cost $4,063 ($130,000 today) to construct. (Courtesy of HV.)

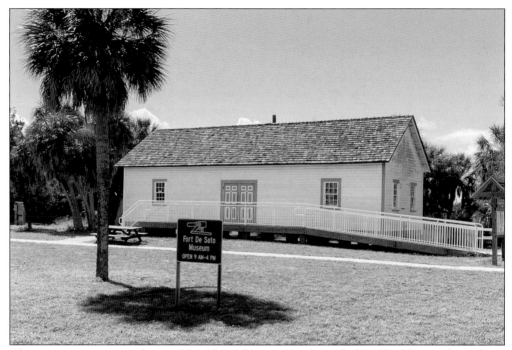

The quartermaster storehouse, No. 10 on the tour, is the only base building to have been reconstructed. In 1999, the Friends of Fort De Soto used photographs, government documents, architects, and park construction experts to faithfully re-create the original building. The first building cost $190 ($6,100) to construct and had 833 square feet of floor space.

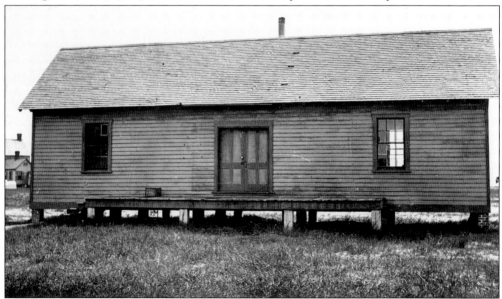

The original quartermaster storehouse, pictured here, was used by the post quartermaster to distribute supplies. Now called the Quartermaster Storehouse Museum, it was dedicated on Veteran's Day in 2000. The museum is a must see destination for anyone interested in fort history as it highlights both the military and daily life of those who served this country at Fort De Soto. (Courtesy of HV.)

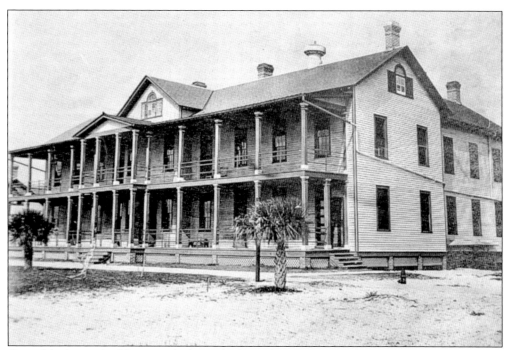

One of the largest buildings on the base, the barracks were 100 feet long and housed 105 enlisted men. The 8,200-square-foot structure, costing $14,599 ($467,000), was heated by fireplaces. Running water and lavatory facilities were out back in a separate building. Structures such as the barracks were built from standardized plans from the Army Quartermaster's Office. Similar barracks, from the same era, still exist at Fort Sam Houston, San Antonio, Texas. (Courtesy of FDS and Phil Schiro.)

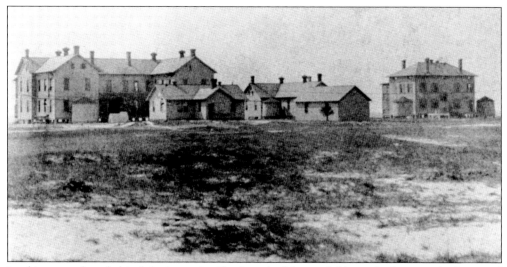

Looking west from behind the barracks (the large building at left) are the lavatory facilities and the fire apparatus house, the smallest building in this image. The large building on the right is the post exchange. None of these buildings have any existing remains. (Courtesy of HV.)

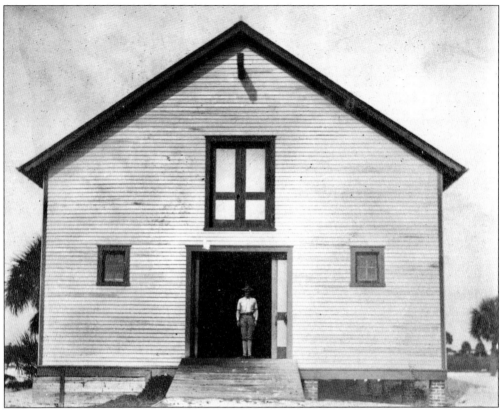

Above, a single soldier proudly stands at attention at the entrance to the wagon shed. Below, many of the buildings previously described can be seen in this photograph taken from the water tower. With Tampa Bay in the background, the buildings on the shoreline are, from left to right, the hospital steward's quarters, the double NCO quarters, the NCO quarters, and the mine storage house (which has no existing foundations). Heading down the left side of the brick main road toward the bay are the wagon shed and the workhouse (both of which have no existing foundations) and the storehouse, quartermaster, and subsistence building. Heading toward the bay down the right side of the wide path are the bakery (set back from the others), the two civilians quarters, and the guardhouse. (Both, courtesy of HV.)

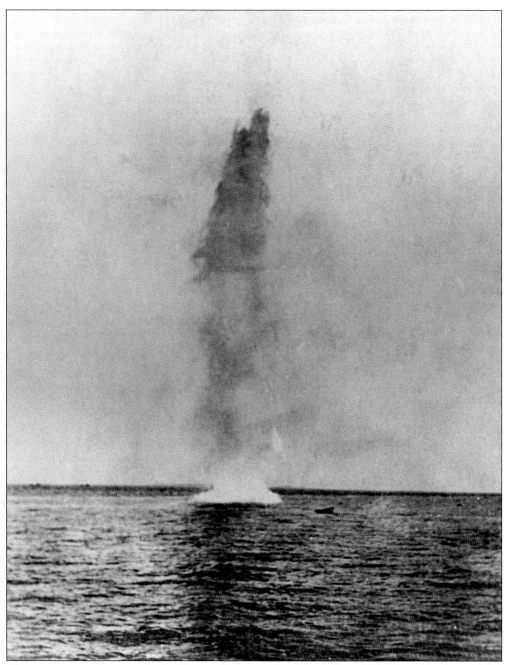

The mine storage house is the building with the single gable at the end of the road leading toward the Gulf in the picture at the bottom of the previous page. Mines could be laid across the channel between Mullet and Egmont Keys and detonated either by contact with a vessel or by remote control from within the mine house. In this photograph, taken between 1905 and 1915, a mine has been detonated out in the channel by remote control. (Courtesy of HV.)

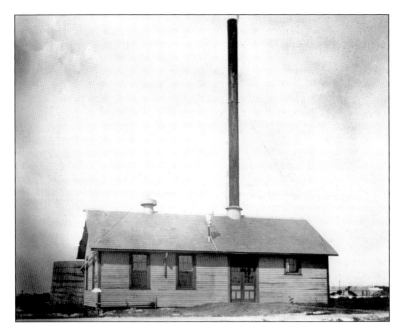

The pump house had a boiler set on a concrete floor to power the steam-driven water pumps. Water was pumped from the wells to the 60,000-gallon water tower. The pump house was built at a cost of $16,064 ($514,000 today). No remains of the pump house exist. (Courtesy of HV.)

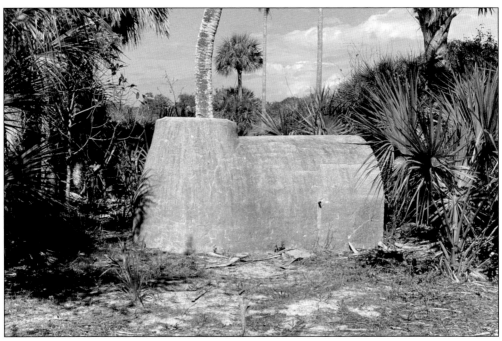

Almost like something out of a Jules Verne novel, the sewer system flush tanks were basically giant versions of a common home toilet tank. Initially, there were four flush tanks used to keep waste moving from the base urinals and toilets into the Gulf of Mexico. There are two left now—one is pictured here, near the hospital, and the other is pictured on page 13, with the single officer's quarters foundation.

No. 19 on the tour is the fire control tower. As can be seen in the photograph on page 13, the tower is an impressive site. This image shows the footings for the original building, which surrounded the concrete tower. Egmont Key is just visible across the water on the left.

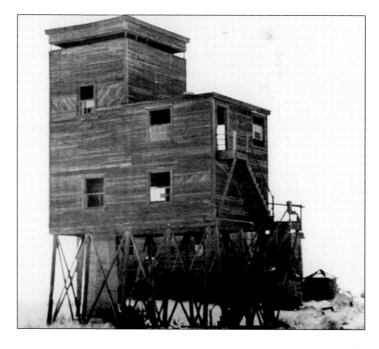

Spotters on lookout in the tower would relay enemy ship position data to the plotting room, located in the structure surrounding the tower. In turn, that data would be sent via telephone to the relocating room housed in Battery Laidley. This information would be triangulated with data sent down from spotters in posts atop the battery. In the case of a power outage, voice tubes were in place from the battery spotters' posts to the rooms below. (Courtesy of HV.)

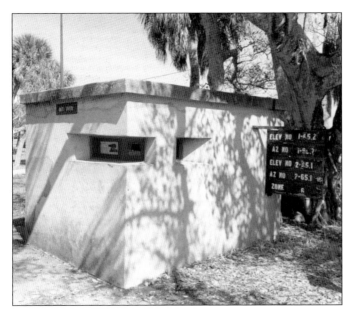

Elevation (vertical plane coordinates) and azimuth (horizontal plane coordinates) from the relocating room would then be relayed by telephone to the data booth, pictured here, which is located just outside a mortar pit. Battery Laidley had two mortar pits, labeled A and B, with a data booth serving each one. The naming of batteries was a nationally significant action, with names ultimately chosen by the secretary of war. Battery names were intended to give inspiration to the soldiers who served them.

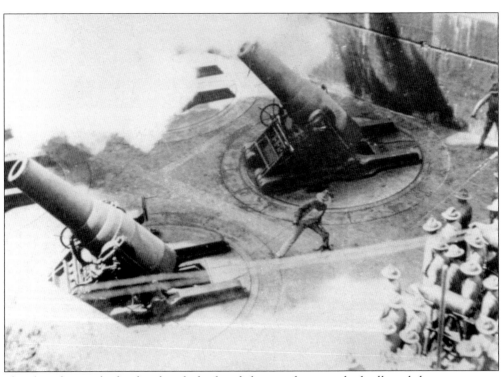

Slate boards outside the data booth displayed the coordinates, which allowed the gun crew to set the gun accordingly and fire when the order was given. The plunging trajectory of the shells was designed to penetrate a ship's deck. In this photograph, a member of the gun crew is awaiting orders to pull the lanyard and fire the mortar. (Courtesy of HV.)

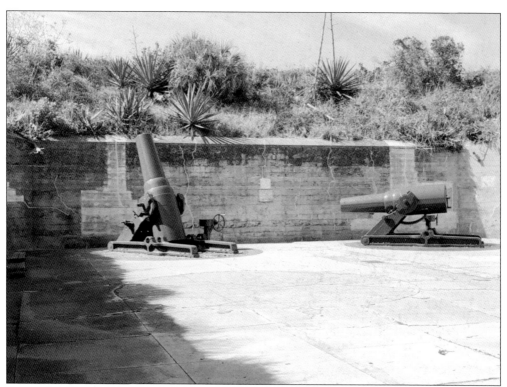

Battery Laidley is named for Col. Theodore T.S. Laidley, who was born in 1822 and was a West Point graduate. Laidley was an ordnance expert and served in the Army for 40 years. Pictured here are two of the four beautifully restored 12-inch mortars on display at Fort De Soto.

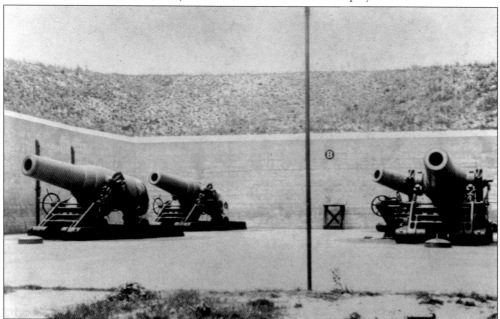

Looking back over a century ago, this is mortar pit B with all four guns intact. The two guns nearest the wall are the same ones as in the previous photograph. (Courtesy of HV.)

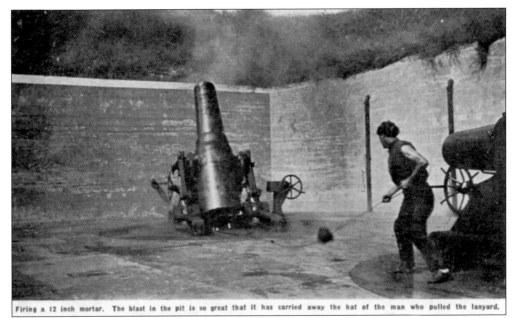

Firing a 12 inch mortar. The blast in the pit is so great that it has carried away the hat of the man who pulled the lanyard.

If, as the postcard caption says, the blast was so great that it blew the hat off this crewman's head, imagine what the noise must have been like! (Courtesy of Alan Shellhorn.)

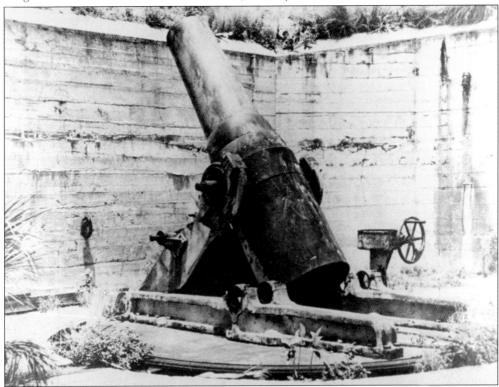

Some unknown number of years later, the same gun looks forlorn and ignored. Since the Spanish-American War ended well over a year before the battery was completed, it has been said that Fort De Soto's mortars "were never fired in anger at an enemy." (Courtesy of HV.)

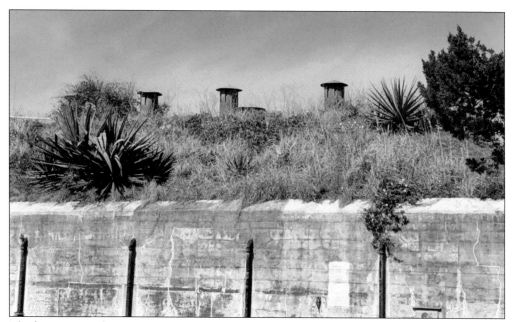

The battery ventilation stacks shown here would have been virtually invisible from any enemy ship trying to enter Tampa Bay. In some cases, in addition to providing a flow of fresh air to the various battery's rooms, the stacks in the gunpowder room were part of a system intended to keep the gunpowder from becoming too moist. Variations in the moisture level of gunpowder could affect the range of the shells.

This image shows ventilation stacks during the fort's construction. After completion, 72,000 cubic feet of sand were laid on top of Battery Laidley to disguise its view from the sea. (Courtesy of HV.)

Battery Bigelow, the remains of which are shown here, was heavily damaged by the hurricane of 1921 and was finally claimed by the sea in 1932. Three-inch-bore short-range guns were emplaced here to cover the one-and-one-quarter-mile shortfall caused by the minimum range of Battery Laidley's big guns.

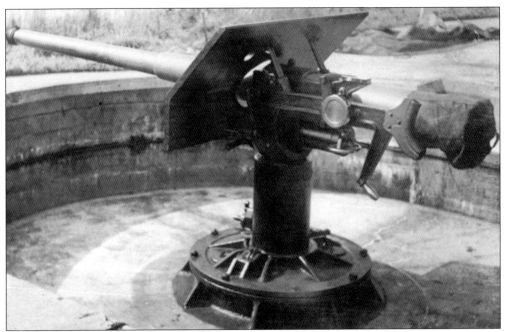

This Driggs-Seabury model M1898-M1 three-inch-bore gun, shown in a 1901 photograph, is the type that was emplaced on Battery Bigelow. The battery was named for Lt. Aaron Bigelow, who died at the Battle of Lundy's Lane in Ontario, Canada, during the War of 1812. Note the gun mounting ring still visible on the contemporary photograph at the top of the page. (Courtesy of the US Army Signal Corps.)

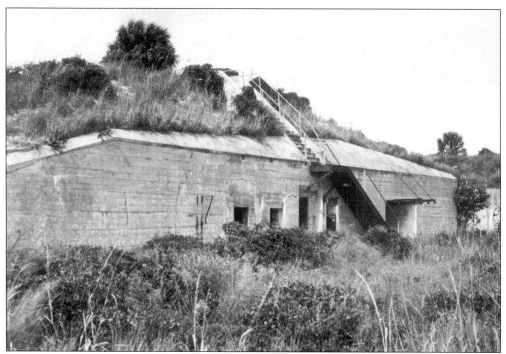

This is what Battery Laidley looked like in 1925, about 15 years after the fort was decommissioned. This battery configuration was new in that previous fort walls were exposed. This new style of fortification had extremely thick concrete walls and ceilings, which were camouflaged by using dirt as a covering. (Courtesy of HV.)

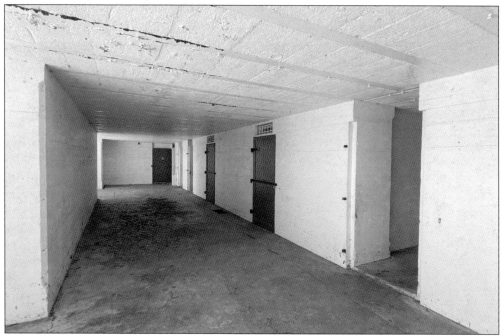

Today, inside the outer walls of Battery Laidley, the hallway leading to the powder magazine, shot room, and fuse room provides a pleasant respite on a hot afternoon.

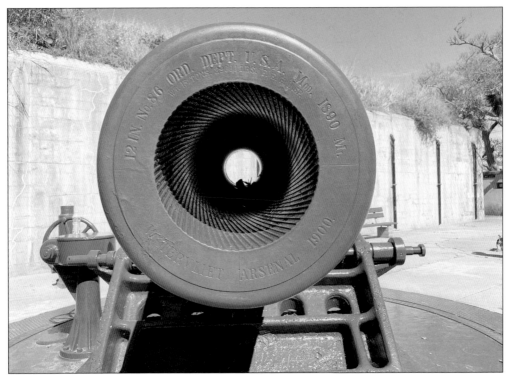

The rifling is easily seen looking down the business end of this 12-inch mortar. These M1890-M1 guns were manufactured by the Watervliet Arsenal in New York and had a range of 6.8 miles.

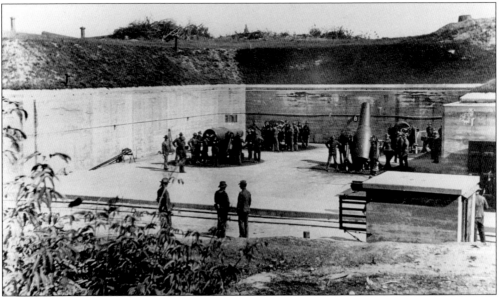

Pretty much the entire contingent is assembled for this mortar exercise around 1910. In the foreground, on the right, a data booth can be seen. A coordinated firing technique called rapid fire, which provided constant bombardment rather than a several-shot volley, was frequently practiced at Fort De Soto. The four 12-inch guns of the type now at Fort De Soto are the only ones left in North America. The only others are in the Philippines. (Courtesy of HV.)

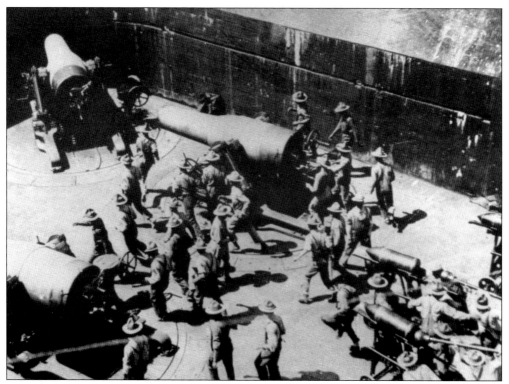

Rapid-fire engagement needed to be a well-choreographed dance. Every gun had 12 men assigned to it, each with a specific task such as loading, targeting, and firing, which required an officer's order. Since the time from siting the target from the observation points to pulling the firing pin was several minutes, the prepping operations for each gun were staggered such that a constant barrage of shells could be directed toward an enemy ship. (Courtesy of HV.)

In this remarkable photograph, the two forward guns have been fired simultaneously and their shells have been frozen in mid-flight. In 1917, four of Battery Laidley's guns were transferred to Fort Rosecrans in San Diego County, California. They were scrapped in 1943. (Courtesy of HV.)

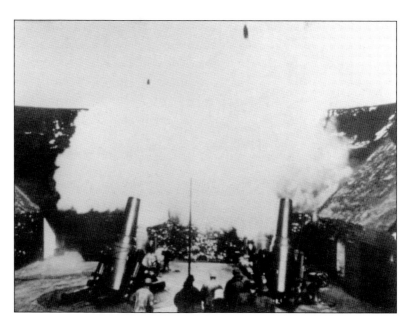

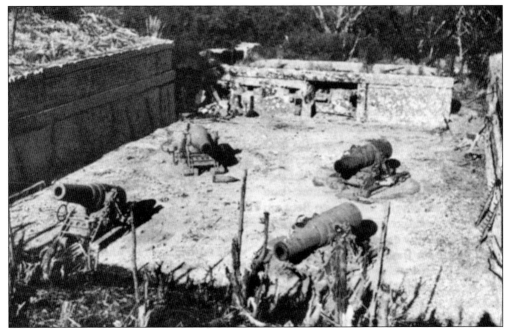

The other four surviving M1890 mortars, pictured here in 1944, are at what used to be Fort Mills in Corregidor, Republic of the Philippines. Unlike the same mortars at Fort De Soto, however, these were very much fired in anger at an enemy, as they served an important role in World War II at the Battle of Corregidor in 1942. (Courtesy of the US Army.)

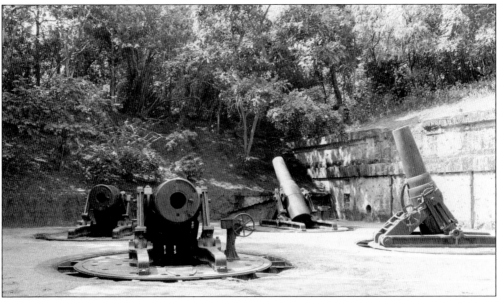

When these mortars were placed into action, the Japanese were caught entirely by surprise, because they had not considered these seemingly obsolete guns in their observations of Corregidor's defenses. As it turned out, due to their vertical shell trajectory, the M1890 mortars were very effective against enemy positions on high ground. Eventually the guns were silenced as the Japanese overtook Corregidor and the Bataan Peninsula. The four mortars now rest in a quiet corner of a Filipino national park. (Courtesy of Matthew Laird Acred.)

This photograph shows one of the two British-built Armstrong six-inch-bore guns now on display at Fort De Soto. Previously, they had been part of Battery Burchstead at Fort Dade on Egmont Key.

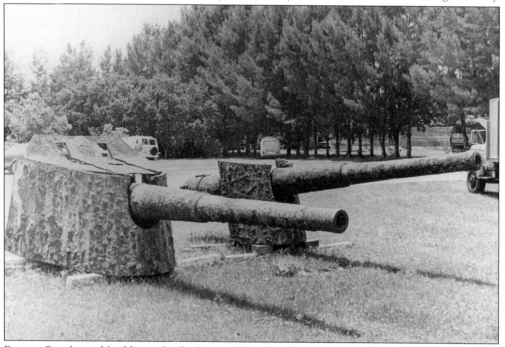

Battery Burchstead had been slowly destroyed by shoreline erosion, and for several decades, the guns sat exposed to the elements. In 1980, they were rescued and brought to Fort De Soto for preservation. They were placed on display near Battery Laidley in 1982. (Courtesy of HV.)

Flip flops now tread where boots once did 120 years ago. This is one of the fort's last remaining original sidewalks.

Two

THE FIRST 842 YEARS

The Tampa Bay area, including the group of islands that now make up Fort De Soto Park and the adjacent Tierra Verde community, has likely been inhabited for thousands of years. The first recorded inhabitants, the Tocobaga, established themselves in the area around 1000 AD. They lived in villages located all around Tampa Bay. Tocobaga villages were near the water's edge, and the tribe subsisted on a wide variety of fish, shellfish, wild game, and local plants.

The Tocobaga were mound builders. These mounds, largely made of sand and shells, were built for various reasons, usually as a burial spot or a place of worship. Tocobaga villages were situated around a plaza-like public area that was used as a meeting place. Estimates put the local native population at the time the Spanish first made contact around 10,000.

Eventually, the Tocobaga largely disappeared due to a combination of intertribal strife, violence against them, and disease brought on by the explorers to which the locals had no natural immunities. The few that did survive are thought to have eventually joined with nearby Seminole tribes.

The first permanent settler of European descent in what is now Tierra Verde is believed to be Capt. William Bunce, originally from Baltimore, Maryland, who set up a fish rancho (fishing village) on Cabbage Key in 1837. The last major bridge before entering Fort De Soto Park crosses Bunces Pass, so named in his honor. Records show that William Bunce died by 1842.

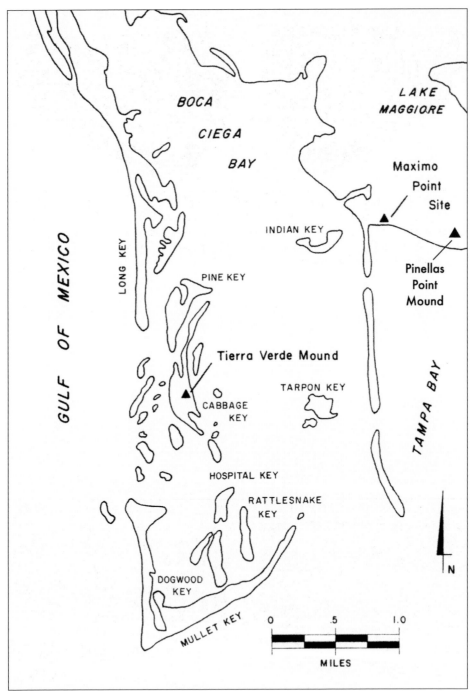

Leaving Fort De Soto Park, a historical marker beside the northbound Pinellas Bayway is the only reminder of local Tocobaga activity that once took place in the Cabbage Key area. It commemorates a burial mound 80 to 100 feet in circumference and 6 to 8 feet high. The deceased were laid to rest along with ceremonial pottery and covered with earth and shells. This 1961 map, showing the location of the mound and other sites, depicts the area before Tierra Verde's development. (Map by William H. Sears.)

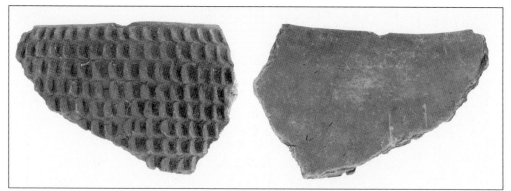

This Tucker Ridge pinched ceramic sherd, from Tierra Verde Tocobaga mound excavations, could date from any time between 300 to 1000 AD. Archaeologist William H. Sears discovered the pieces on this page during a 1961 excavation prior to the destruction of the Tierra Verde mound in order to accommodate the building of the Pinellas Bayway. (Courtesy of Lori Collins, Travis Doering, and Jorge Gonzalez, USF.)

This incised rim sherd, likely dating from between 900 and 1100 AD, was part of a large, open bowl. The type of ceramic used here is typical of Tocobaga mortuary pottery of that period. These artifacts, and many fascinating others, can be viewed in 3-D by accessing the Florida Archaeological Parks and Artifact Collections–Digital Heritage and Humanities Collections, University of South Florida. (Courtesy of Lori Collins, Travis Doering, and Jorge Gonzalez, USF.)

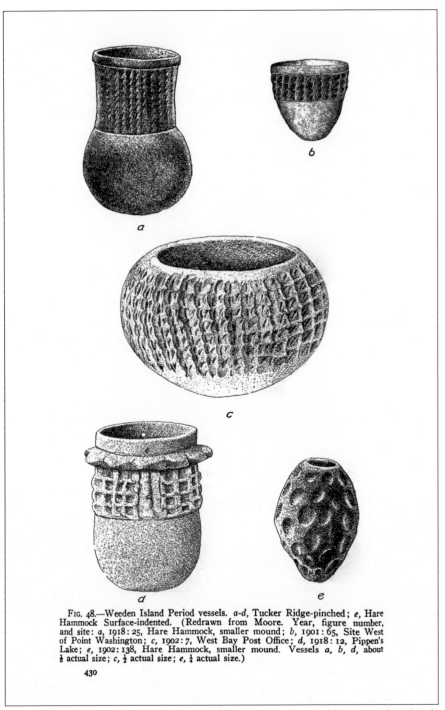

FIG. 48.—Weeden Island Period vessels. *a-d*, Tucker Ridge-pinched; *e*, Hare Hammock Surface-indented. (Redrawn from Moore. Year, figure number, and site: *a*, 1918:25, Hare Hammock, smaller mound; *b*, 1901:65, Site West of Point Washington; *c*, 1902:7, West Bay Post Office; *d*, 1918:12, Pippen's Lake; *e*, 1902:138, Hare Hammock, smaller mound. Vessels *a*, *b*, *d*, about ⅓ actual size; *c*, ½ actual size; *e*, ¼ actual size.)

430

The center illustration on this page (labeled C) is an example of what a complete bowl of the Tucker Ridge pinched sherds would look like. This particular bowl was excavated in 1902 in Bay County, Florida. Archaeological examinations and reports regarding the Tierra Verde mound have been conducted and written by S.T. Walker in 1879, Clarence B. Moore in 1900, and William Sears in 1961. (Courtesy of the Smithsonian Institution.)

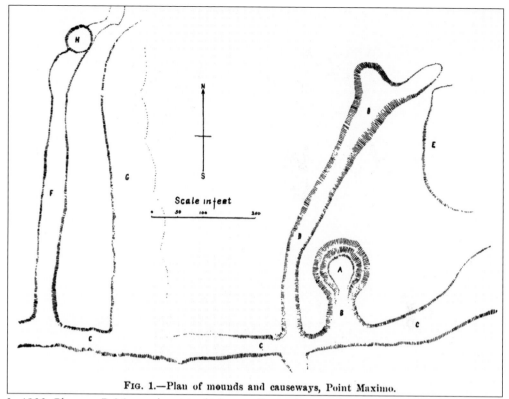

FIG. 1.—Plan of mounds and causeways, Point Maximo.

In 1900, Clarence B. Moore also visited Maximo Point, the site of an important Tocobaga village, and created this map, published in Gordon Willey's *Archeology of the Florida Gulf Coast* in 1949. William Sears theorized that, based on Moore's findings, the Tierra Verde mound and the Maximo village were connected. Shown on this map are A) temple mound, 10 feet high, 100-foot diameter; B) ridge of shell; C) ridge running parallel to the water; D) "Curious ridge," 700 feet long, 6 feet high; E) sand causeway; F and G) 500-foot embankments; and H) sand mound.

The Pinellas Point Temple Mound, sometimes called the Princess or Hirrihigua mound, is seen here in the 1950s, about the same time as the last days of the Tierra Verde mound, which is just a few miles away. Like most Tocobaga mounds, it is made of shells and earth and was built before 1000 AD. The flat surface is indicative of a temple mound in that such a surface was necessary for construction. (Courtesy of the St. Petersburg Historical Museum.)

The Pinellas Point mound is seen from the same view today. Temple mounds were used by the Tocobaga as places of worship. Sacred items would be kept there, and a religious leader or chief may have also lived there. Archaeologists have determined that this mound had at least one building on it and was surrounded by a village with a population of at least 400.

The neighborhood in which the mound is located, viewed here from the east, is known in St. Petersburg as the "Pink Streets." Performing a Google Earth search of the site and using satellite view will provide the proof! That the mound exists at all, surrounded by homes in a residential neighborhood, is due to the generosity of local citizen Ed C. Wright, who donated the land to the city in 1958.

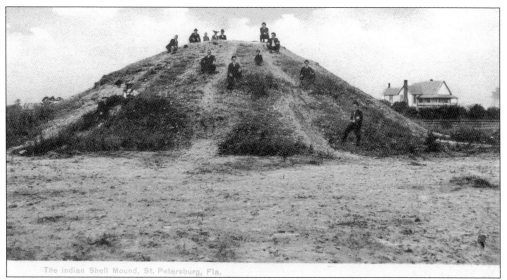

The Indian Shell Mound, St. Petersburg, Fla.

St. Petersburg's most celebrated Native American mound, yet the least understood, was this one simply called the Shell Mound due to its oyster shell construction. It stood on the spot now occupied by Bayfront Health, a few blocks south of downtown. This mound has appeared in at least 20 different postcards, including this one from around 1900. Still-existing Pinellas County mounds can be found at Maximo Park, Weedon Island Preserve, Jungle Prada Park, and Philippe Park. (Courtesy of FM.)

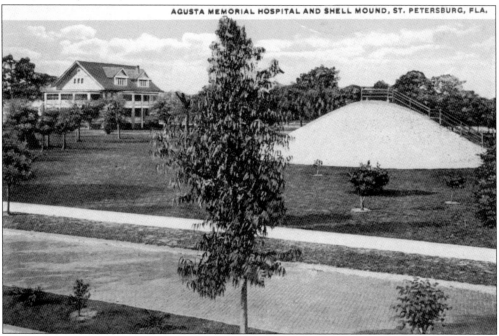

AGUSTA MEMORIAL HOSPITAL AND SHELL MOUND, ST. PETERSBURG, FLA.

Shown here in 1916, the purpose of the Shell Mound is unknown. The wrong shape to be a temple mound and with no evidence of being a burial mound, it may have been used as an observation point. In 1915, the city "cleaned up" the mound with a fire hose, turning its appearance an unnatural white. It was bulldozed in 1950 for an extension of Mound Park Hospital, previously called Augusta Memorial. (Courtesy of USF Digital Collections.)

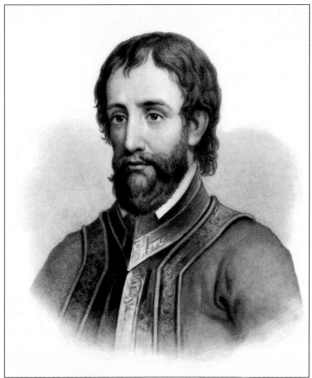

The birth date of Hernando de Soto, pictured here, is not precisely known but is thought to be in 1496 or 1497. Born in what is now Badajoz, Spain, of parents who were minor nobles, he was educated at the University of Salamanca. De Soto made his first journey to the New World in 1514 with Pedro Arias Davila, who appointed him a captain in the cavalry. This engraving was done by John Sartain in 1858. (Courtesy of LC.)

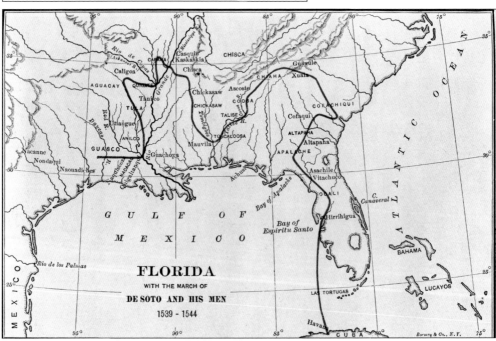

De Soto's 1539–1544 expedition is outlined on this map. The place name Hirrihigua, near present-day Tampa Bay, refers to the domain of Tocobaga chief Hirrihigua. De Soto himself did not finish the expedition, having died of a fever on May 21, 1542. He was buried in the Mississippi River. Luis de Moscoso Alvorado took command of the journey, as de Soto wished. (Courtesy of LC.)

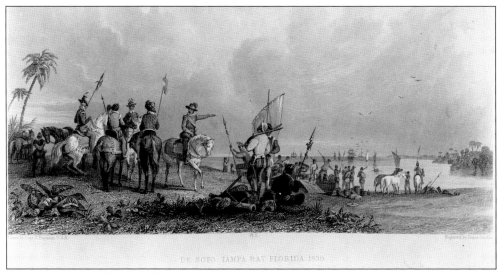

De Soto Tampa Bay Florida 1539 depicts de Soto's initial landing on the North American continent. The actual landing spot is open to debate, with some scholars claiming the expedition's landfall to be near present-day Bradenton on Tampa Bay, while others believe it to be near Charlotte Harbor, 100 miles to the south. This engraving was done by James Smillie in 1853 from a drawing by US Army captain S. Eastman. (Courtesy of LC.)

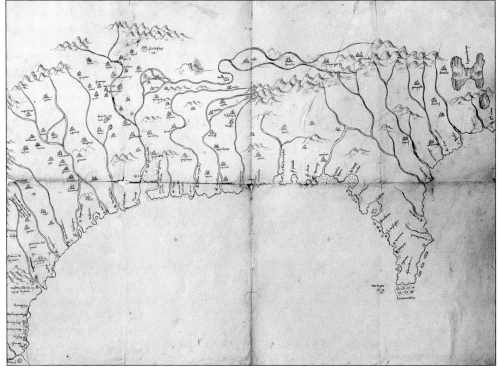

Sometime before his death in 1567, Spanish cartographer Alonso de Santa Cruz produced this map entitled "Map of the Gulf and Coast of New Spain." It is quite likely that information provided by expeditions such as Ponce de Leon's, who first visited Florida in 1513, and de Soto's helped to produce this result, which was published in 1572. (Courtesy of LC.)

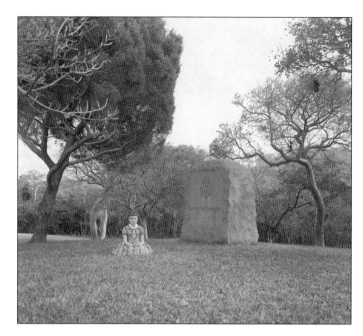

Although de Soto's first landfall in Florida is up for discussion, the town of Bradenton won the prize when it was awarded the De Soto National Memorial on March 11, 1948. Located on Shaw's Point, the 26-acre park is administered by the National Park Service. Pictured here, Ginger Crawford poses by the De Soto Monument at the park in February 1960. She was photographed by Charles Barron of the Florida State Development Commission. (Courtesy of FM.)

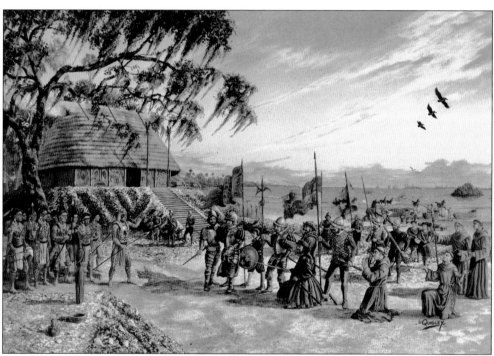

Trained archaeologist and acclaimed painter Dean Quigley provides a glimpse at what the scene may have looked like when de Soto landed at the spot where Ginger Crawford is seated in the top image. The image provides an excellent example of how Tocobaga temple mounds may have appeared.

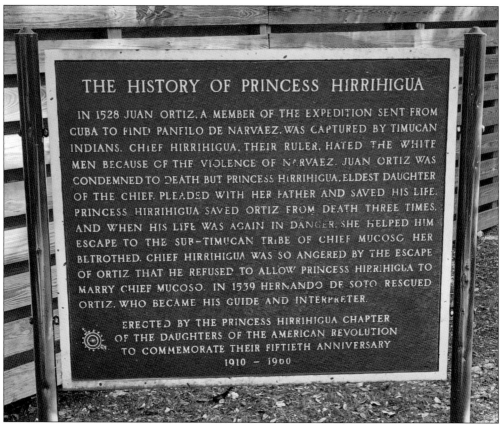

THE HISTORY OF PRINCESS HIRRIHIGUA

IN 1528 JUAN ORTIZ, A MEMBER OF THE EXPEDITION SENT FROM
CUBA TO FIND PANFILO DE NARVAEZ, WAS CAPTURED BY TIMUCAN
INDIANS. CHIEF HIRRIHIGUA, THEIR RULER, HATED THE WHITE
MEN BECAUSE OF THE VIOLENCE OF NARVAEZ. JUAN ORTIZ WAS
CONDEMNED TO DEATH BUT PRINCESS HIRRIHIGUA, ELDEST DAUGHTER
OF THE CHIEF, PLEADED WITH HER FATHER AND SAVED HIS LIFE.
PRINCESS HIRRIHIGUA SAVED ORTIZ FROM DEATH THREE TIMES,
AND WHEN HIS LIFE WAS AGAIN IN DANGER, SHE HELPED HIM
ESCAPE TO THE SUB-TIMUCAN TRIBE OF CHIEF MUCOSO HER
BETROTHED. CHIEF HIRRIHIGUA WAS SO ANGERED BY THE ESCAPE
OF ORTIZ THAT HE REFUSED TO ALLOW PRINCESS HIRRIHIGUA TO
MARRY CHIEF MUCOSO. IN 1539 HERNANDO DE SOTO RESCUED
ORTIZ, WHO BECAME HIS GUIDE AND INTERPRETER.

ERECTED BY THE PRINCESS HIRRIHIGUA CHAPTER
OF THE DAUGHTERS OF THE AMERICAN REVOLUTION
TO COMMEMORATE THEIR FIFTIETH ANNIVERSARY
1910 — 1960

At the site of the Pinellas Point Temple Mound is this historical marker placed by the Princess Hirrihigua Chapter of the Daughters of the American Revolution in 1960. The story it tells sounds strangely similar to the Pocahontas tale.

In Lambert A. Wilmer's *The Life, Travels and Adventures of Ferdinand De Soto, Discoverer of the Mississippi* (1858), his illustrator J.W. Orr shows how the escape happened.

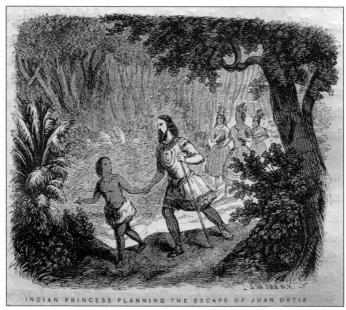

INDIAN PRINCESS PLANNING THE ESCAPE OF JUAN ORTIZ

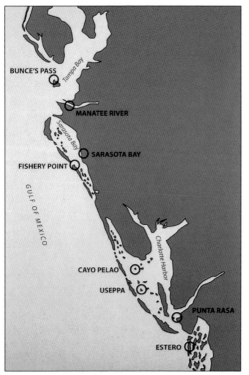

In 1837, Maryland-born merchant sea captain William Bunce became the first person of European descent to settle on the islands that are now Tierra Verde and Fort De Soto Park. Three years earlier, Bunce had set up a fish rancho on the Manatee River, employing up to 150 Native Americans, Cubans, and others to serve Havana's fish market. Shown here are the major fish ranchos on Florida's west coast between 1760 and 1840, two of which were Bunce's. (Courtesy of Meg Stack, USF master's thesis, 2006.)

William Bunce's rancho workers lived in palmetto frond shacks similar to the one depicted in this 1910 postcard. When the First Seminole War broke out, Federal troops, suspecting that Native Americans working at Bunce's rancho were Seminoles, ordered their surrender. Bunce refused, arguing that the Native Americans working for him were local and not Seminole. Ignoring his argument, the troops destroyed his business and dispersed his workers.

Unbowed, William Bunce moved his operation to Cabbage Key, now part of Tierra Verde. Bunces Pass, crossed over by the final bridge before reaching Fort De Soto Park, is named in his honor. In 1840, the continuing hostilities of the Seminole Wars caught up with Bunce again. This rancho, too, was burned by Federal troops, their commander convinced that he was a Seminole sympathizer. This 1837 lithograph by Gray & James depicts a similar village burning. In this instance, Federal troops burn a Seminole village. (Courtesy of LC.)

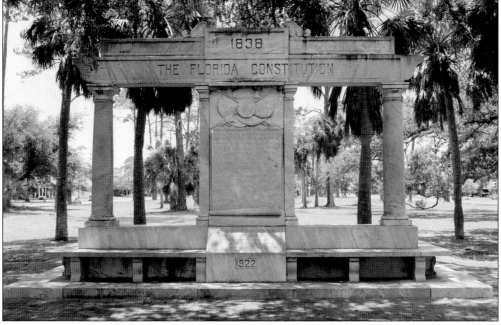

Despite all this, William Bunce was chosen as a delegate to the Florida Constitutional Convention, held in 1838 at St. Joseph, Florida. This monument commemorating Florida's constitution is on the grounds of the Florida Constitution Museum in the town now called Port St. Joe. The original town was abandoned in 1854 after a severe yellow fever outbreak followed by several devastating storms. In 2013, Port St. Joe celebrated the centennial of its 1913 rebirth. Records indicate that William Bunce died sometime before early 1842. (Photograph by Tim Nelson.)

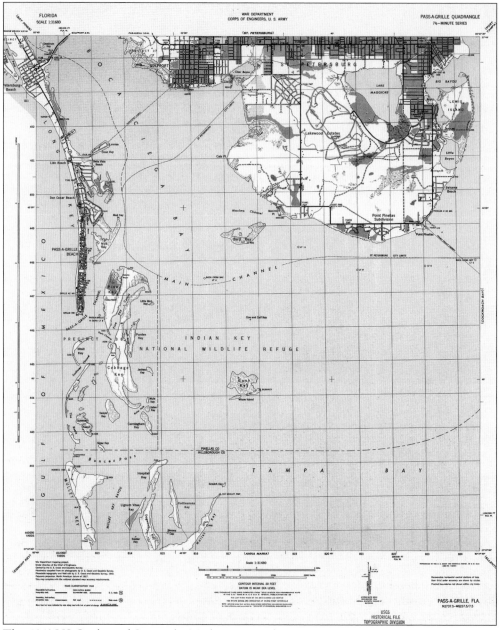

This 1943 US Geological Survey (USGS) map provides a perspective of predevelopment at lower Boca Ciega Bay. Many of the sites mentioned in this chapter, including Maximo Point, Cabbage Key, Bunces Pass, and most of Mullet Key (but not the section with the fort) can be seen here. The Princess Mound is located in the southeast section of the area labeled "Pinellas Point Subdivision." The St. Petersburg Shell Mound (not located on this map) was located about a dozen blocks north from the top right of this map. Egmont Key, the home of Fort Dade, is just off the bottom left of the map. Within 20 years, landfill and bridges would link a road from Maximo Point to Pine Key and on to Pass-a-Grille, with a spur down to Fort De Soto Park. (Courtesy of the USGS.)

Three

FORT LIFE

In 1908, the Fort De Soto quartermaster presented this report:

> The suffering of the men daily while at work or drill has been greater than can be imagined by any who have not actually experienced it. There have been many nights that the men have had no sleep due to the mosquitoes in quarters, even though mosquito bars are used. . . . At present life for the men is a torture both night and day and the mosquitoes have to be fought with a bush whether at work or resting.

In addition to the mosquitoes, isolation, and boredom were other factors in Fort De Soto's unpopularity as a duty station. Recreation opportunities were minimal, as there was no telephone service available and just one boat a day provided the only link to the outside world. In 1904, Brig. Gen. T.H. Barry, commander of the Department of the Gulf, recommended that beer and light wines be sold in the post exchange in order to add to the "contentment and discipline" of the men. With significant improvements in mobile land-based artillery, fixed coastal posts such as Fort De Soto became obsolete. In 1910, the fort was decommissioned with only a small caretaker unit staffing it until 1917, when the detachment was increased due to the advent of World War I. By 1923, both Fort De Soto and Fort Dade were abandoned with just one caretaker each to oversee the property. Despite the boredom and hardship, the garrison did find time to relax, entertain themselves, and even enjoy the company of their friends and families.

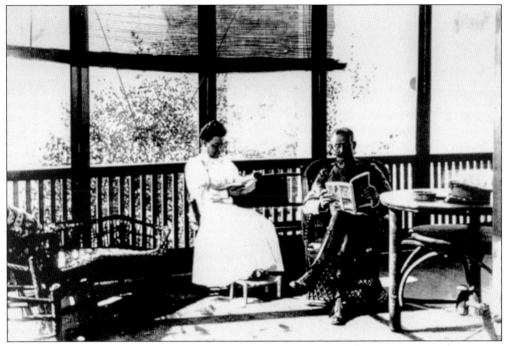

Captain and Mrs. Wilcox relax on the porch at the commanding officer's quarters. The captain is reported to be reading the December 1904 issue of *McLure's Magazine*. (Courtesy of FDS and Phil Schiro.)

Three unidentified women rest on the front steps of the commanding officer's quarters on a quite afternoon around 1910. (Courtesy of HV.)

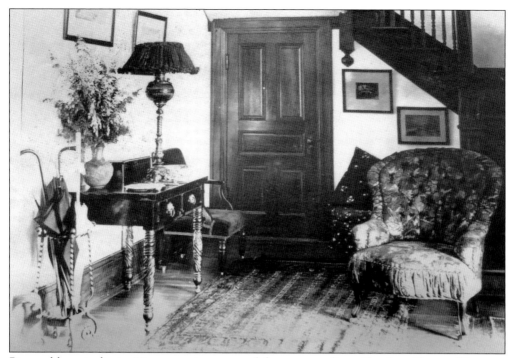

Pictured here is the inviting reception room of the commanding officer's residence. (Courtesy of FDS and Phil Schiro.)

A rare glimpse of turn-of-the-20th-century daily life is visible in this image of the captain's dining room. Note the fine silver displayed on the hutch behind the table. (Courtesy of FDS and Phil Schiro.)

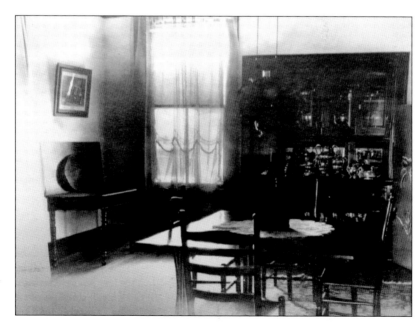

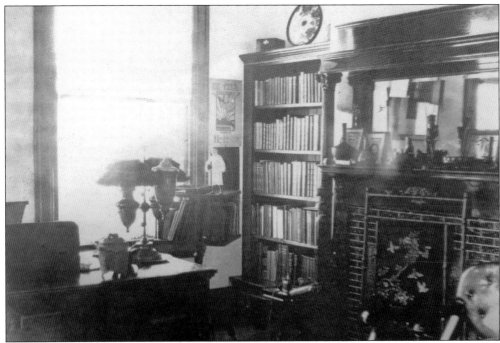

A poster to the right of the window in the study proudly displays West Point's 11-6 victory over Yale in their 1904 football matchup. Until this victory, Army had never beaten powerful Yale, having previously gone 0-8-3 against the Bulldogs. For a clear image of the poster, search www.westpointaog.org/army-yale-football, with thanks to the West Point Association of Graduates. (Courtesy of FDS and Phil Schiro.)

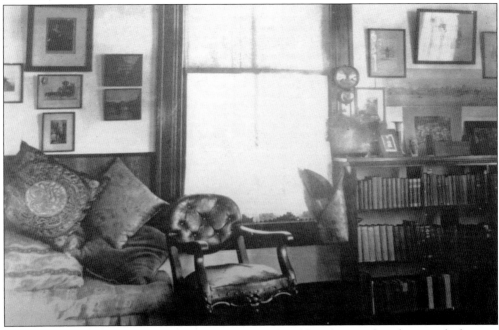

The captain's mementos and pictures provide a comfortable refuge in this photograph showing a different view of his study. (Courtesy of FDS and Phil Schiro.)

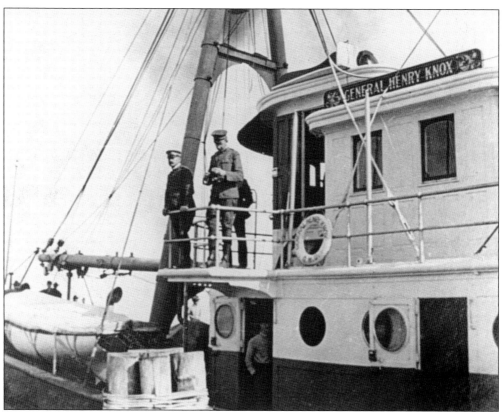

The US Army mine planter (USAMP) *Henry Knox* plied the waters between Fort Dade, on Egmont Key, and Fort De Soto. Named for the American Revolution war hero Gen. Henry Knox, who was also the first secretary of war, the ship was launched on March 5, 1904. Here, passengers and crew on both decks enjoy the sea air as they cross the channel between the two forts. (Courtesy of HV.)

Around 1910, the *Henry Knox* is seen from stem to stern as it crosses the channel between Mullet Key and Egmont Key. (Courtesy of HV.)

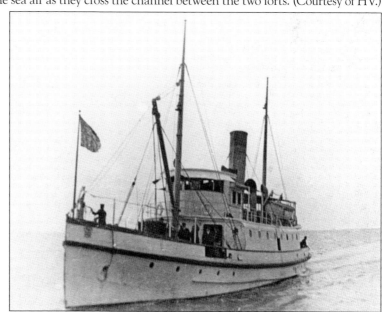

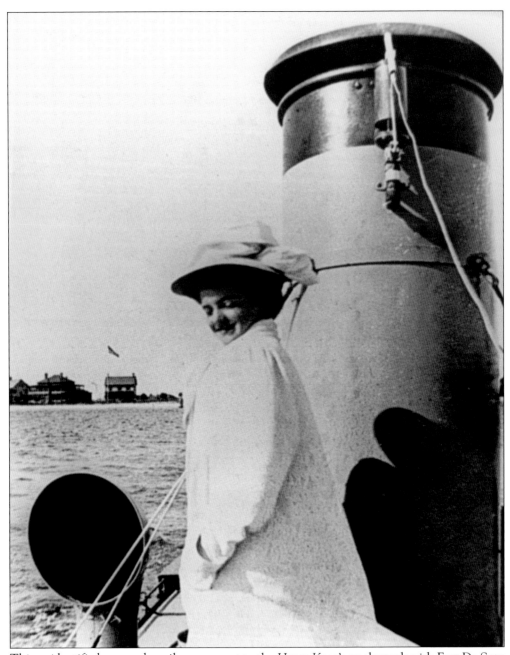

This unidentified woman happily poses next to the *Henry Knox*'s smokestack with Fort De Soto in the background. On the shore are, from left to right, one of the single officer's quarters, the commanding officer's quarters, and the fort's administration building. In 1920, the *Henry Knox* was sent to serve at Fort Mills in the Philippines—the same former fort where the only other Watervliet M1890 mortars are located. (Courtesy of HV.)

A Fort De Soto officer holding his Kodak Brownie camera poses with an unidentified but very self-assured looking man on the deck of the *Henry Knox.* Brownies were introduced by Kodak in 1900 and made it possible for anyone to take a snapshot using a simple roll of film. More than likely, most of the photographs of the fort's everyday life were taken by Brownies. (Courtesy of HV.)

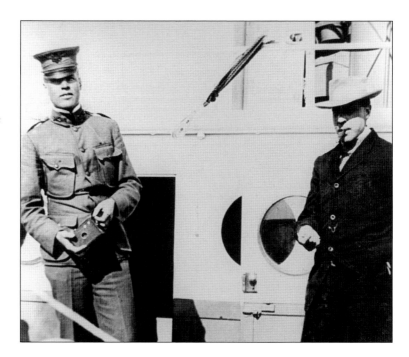

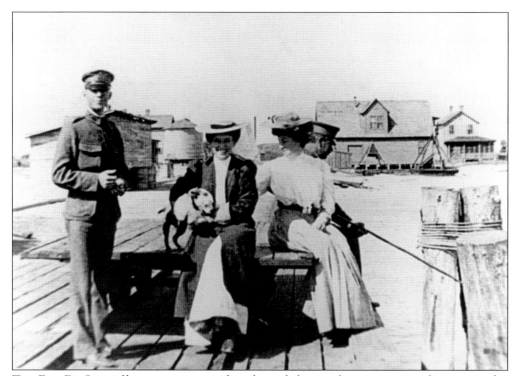

Two Fort De Soto officers, two women friends, and the usual uncooperative dog enjoy a day of fishing on the fort's dock. In the background at right are the mine storage and the single noncommissioned officer's quarters. The two pyramid-shaped objects in front of the mine storage building are target rafts. (Courtesy of HV.)

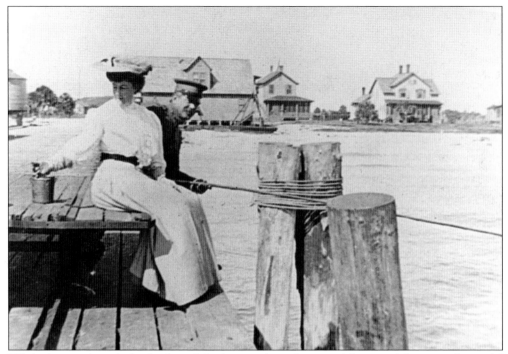

While the couple with the dog have left, this couple sticks around for more fishing on a beautiful day. They are both sitting on a narrow-gauge railroad handcart, which was used to move freight off-loaded from ships to locations within the fort. In addition to the mine house, directly behind the couple, is the single noncommissioned officer's quarters, with the double noncommissioned officers' quarters to its right. (Courtesy of HV.)

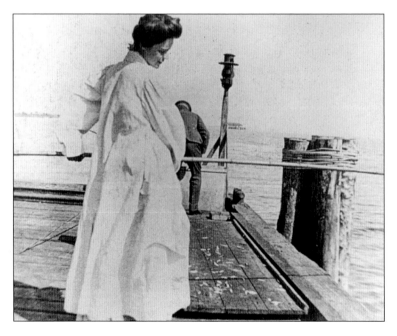

More fishing, this time with a woman and her soldier companion, takes place on the dock. The wharf of the Mullet Key quarantine station can be seen in the distance. (Courtesy of HV.)

On what must have been a very slow day at the fort, these two soldiers decided to wear funny hats. Clearly, the man on the right wins the prize with his bonnet. The gun is certainly an interesting touch. (Courtesy of HV.)

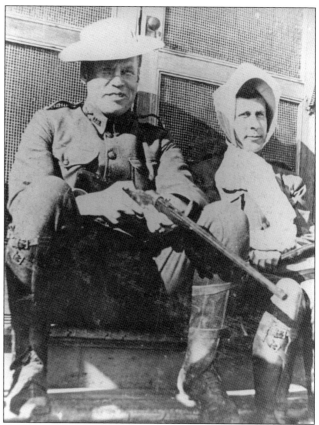

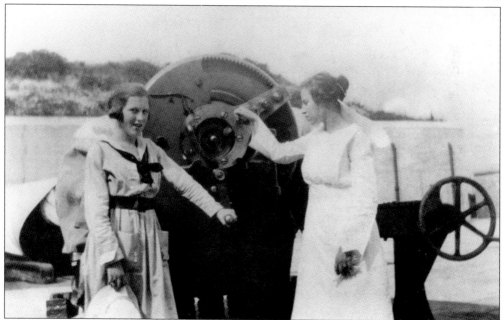

These young women decided to personally inspect the 12-inch mortars at Battery Laidley sometime around 1915. (Courtesy of HV.)

The Fort De Soto post exchange, pictured here but with no existing foundations, was akin to a trading post. The post exchange (now commonly called the PX) was a place where base personnel could purchase personal items, such as shaving gear or tobacco, that the Army did not provide. (Courtesy of HV.)

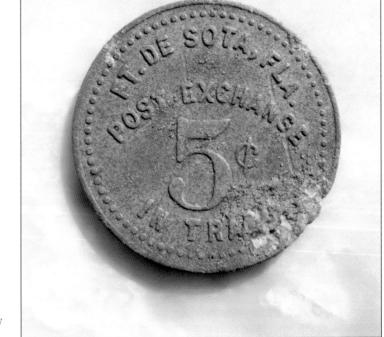

The fort had its own coinage, which could be used at the PX. In 1900, five cents could buy a tin of cookies, a magazine, or a pound of oyster crackers. A decent straight razor would cost around $2 ($64 today). (Courtesy of Alan Shellhorn.)

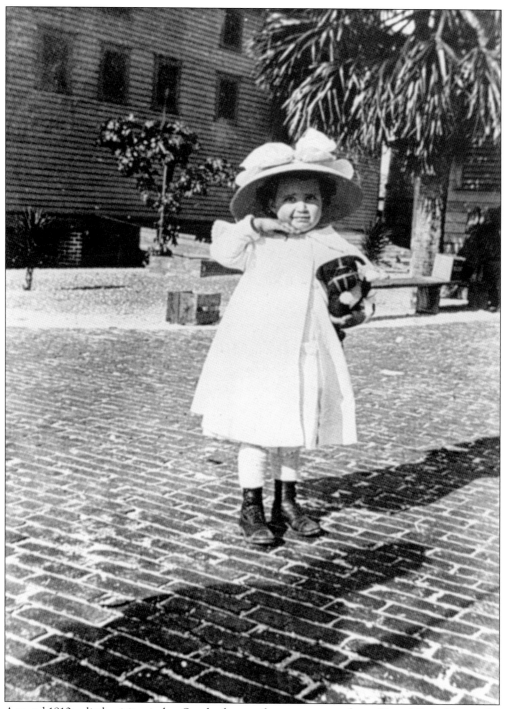

Around 1910, a little visitor in her Sunday best strikes a pose near the stables while holding tight to the stuffed animal in her left arm. (Courtesy of HV.)

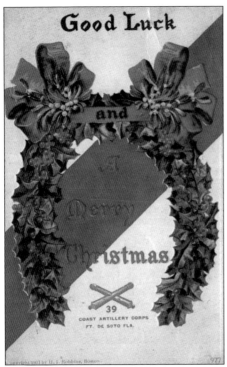

Fort De Soto servicemen had their very own Christmas postcard to send out to friends and loved ones. This card was made for Christmas 1907 by the H.I. Robbins Company of Boston. (Courtesy of Allen Shellhorn.)

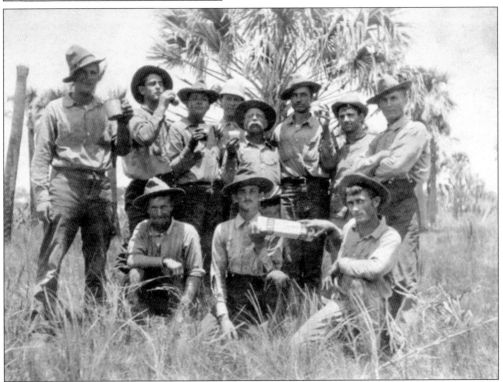

The soldiers down front have apparently just visited the PX, as they are reportedly holding a box of crackers. The rest of them seem to be toasting the purchase. (Courtesy of FDS and Phil Schiro.)

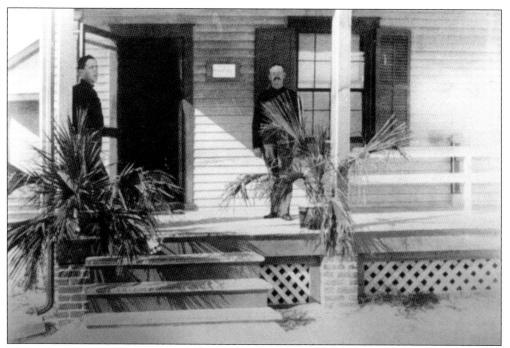

These two men enjoy a moment of fresh air outside of the post office located at the double noncommissioned officers' quarters. (Courtesy of FDS and Phil Schiro.)

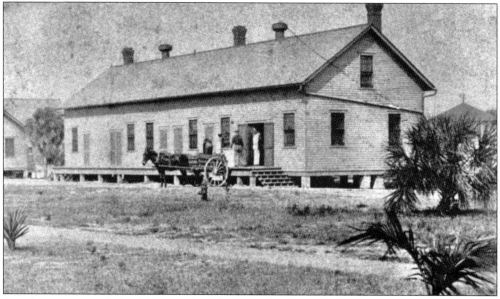

A mule waits patiently for this cart to be unloaded at the storehouse, quartermaster, and subsistence building. (Courtesy of HV.)

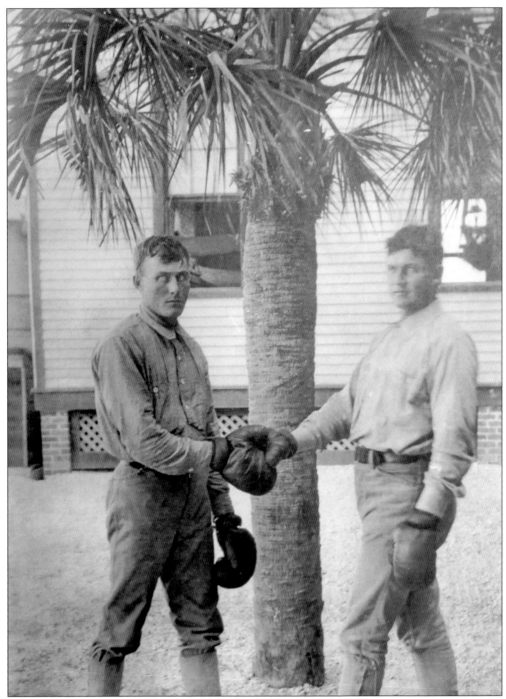

With very few options for recreation at Fort De Soto, boxing smokers (an informal match) provided a healthy diversion. Here, two soldiers shake hands before their 1904 bout. In a 2002 web site essay posted from Camp Commando in Kuwait, Marine sergeant Arbez Cruz explained boxing's importance: "We're working around the clock, and this gives us an opportunity to stop working, have fun, and relieve some stress in the ring." (Courtesy of FDS and Phil Schiro.)

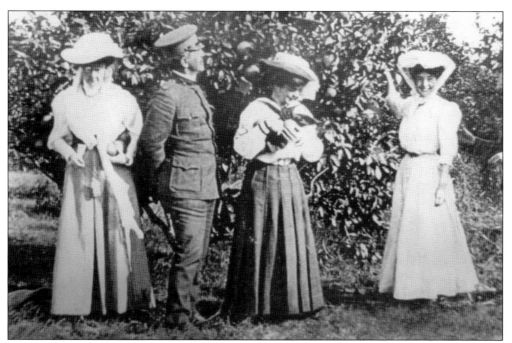

Two officers, one partially visible on the extreme right, and three unidentified women enjoy some time off base (and off Mullet Key) by visiting a nearby orange grove. This c. 1905 photograph was probably taken in Bradenton. (Courtesy of FDS and Phil Schiro.)

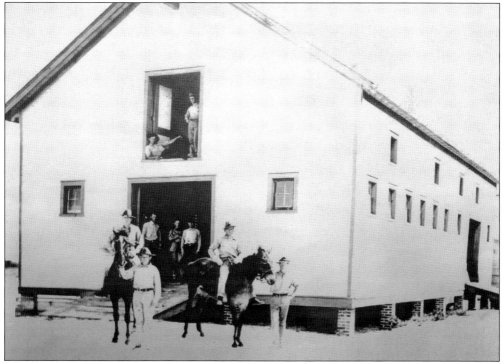

In addition to the men, a horse (left) and a mule (right) share this scene at the stables. (Courtesy of FDS and Phil Schiro.)

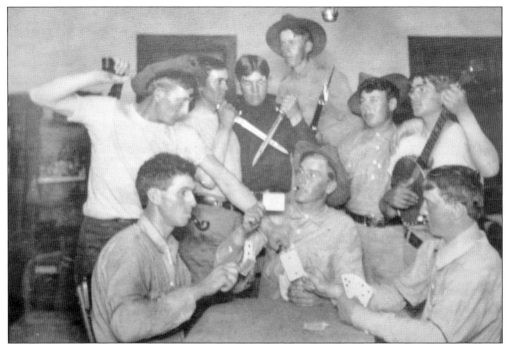

Like the two soldiers wearing silly hats a few pages back, hamming it up for the camera seemed to be a popular form of recreation. Pictured here seems to be a crooked card game, some angry spectators, and a man on the banjo providing musical accompaniment. (Courtesy of FDS and Phil Schiro.)

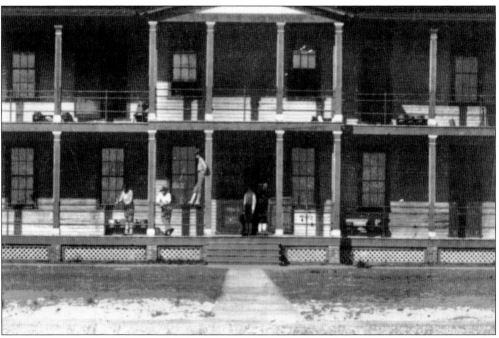

On another apparently lazy day, a handful of soldiers look somewhat bored as they pose on the porch of the barracks. (Courtesy of HV.)

With the banjo player front and center and someone holding playing cards on the right, several soldiers are seen relaxing in the barracks squad room. (Courtesy of FDS and Phil Schiro.)

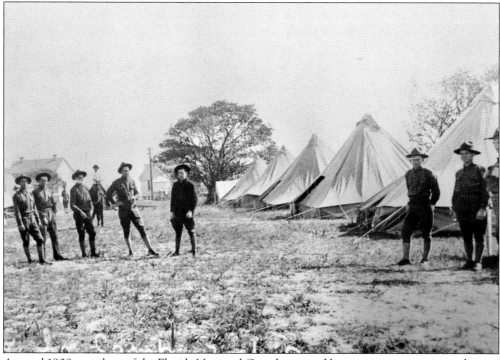

Around 1909, members of the Florida National Guard, pictured here, are seen prior to conducting joint maneuvers with the troops at Fort De Soto. (Courtesy of FDS and Phil Schiro.)

The advent of the Brownie camera led to countless photographs ending up like this; the young woman here does not seem happy about getting her picture taken. In this 1906 image, the civilian quarters are on the left while the very tall pump house chimney is in the background. (Courtesy of HV.)

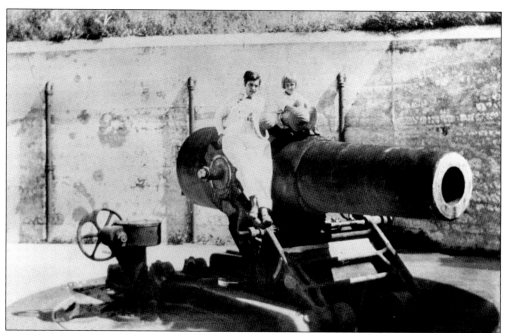

Once the fort was closed in 1923, the mortars were available for climbing. These two visitors, holding their sombreros, were taking part in a Knight & Wall company picnic in the 1920s. According to TampaPix.com, Knight & Wall hardware and sporting goods company of Tampa was at one time the largest hardware establishment in Florida. Cofounder Perry G. Wall II was mayor of Tampa from 1924 to 1928. (Courtesy of HV.)

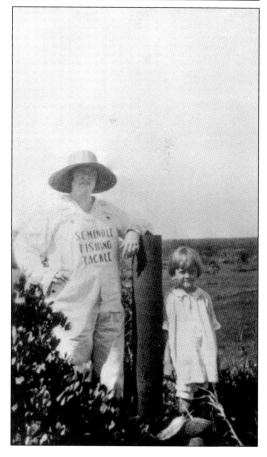

"Seminole Fishing Tackle" (likely a store product line) overalls seemed to be the outfit of the day for the company picnic, as the person on the left in the previous picture is also wearing them, although the lettering is difficult to read. The use of the Fort De Soto grounds for outings such as this marks the fort's transition from military reservation to recreational destination. (Courtesy of HV.)

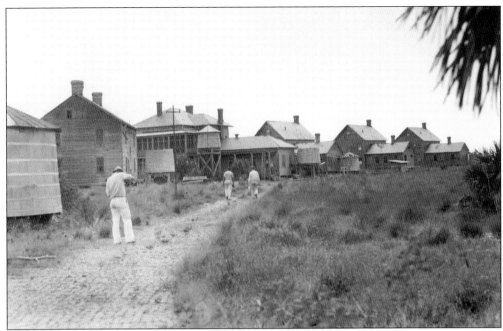

Sometime in the 1930s, three unidentified visitors wander among these abandoned Fort De Soto buildings, once the nerve center of the fort. Seen from the rear, these structures are, from left to right, the administration building, the commanding officer's quarters, and the three junior officers' quarters. (Courtesy of HV.)

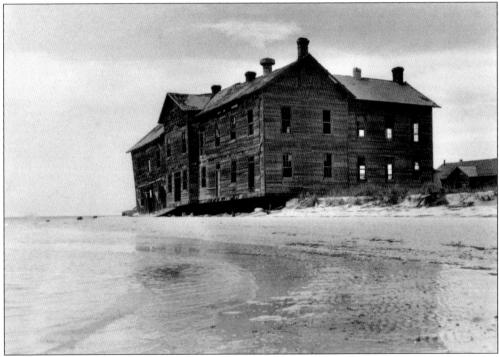

In this photograph from June 1931, the once lively barracks look sadly forlorn, suffering from beach erosion. (Courtesy of HV.)

Four

MULLET KEY

In 1889, a quarantine station was established on Mullet Key due to concerns regarding the spread of infectious diseases, especially yellow fever. The station served as a short-term isolation center for travelers coming to the Tampa Bay area, including non–US citizens aboard vessels arriving from foreign ports. By 1925, it consisted of 15 buildings. The quarantine station suffered from some of the same major drawbacks as Fort De Soto, mainly the miserable mosquito problem and isolation. In 1930, the isolation issue was relieved somewhat when a telephone cable was laid to St. Petersburg. Meanwhile, the Public Health Service personnel living at the station were being forced indoors during the summer due to the pernicious insects. In 1933, the problem was solved with successful mosquito eradication. The quarantine station was closed in 1937, when all Public Health Service quarantine operations were centralized at Gadsden Point, near Tampa. In 1938, all 27 acres of the station, including the buildings, were sold to Pinellas County.

After decommissioning in 1910, Fort De Soto was primarily being used as a hunting preserve for soldiers from nearby Fort Dade. In March 1913, Congress authorized the Department of Agriculture to adopt regulations putting in place closed hunting seasons for migratory game and insect-eating birds. The act further instructed states to appoint wardens to monitor and enforce the regulations. In August 1913, the Department of War permitted the use of one of the fort's buildings as a residence for the new warden. In 1935, the department authorized as a bird sanctuary most of the Fort De Soto reservation, including North Mullet, Rattlesnake, and Hospital Keys. Mullet Key itself was not part of the agreement, as the City of St. Petersburg had expressed an interest in a long-term lease of that island.

With World War II already raging in Europe, the Army entered into negotiations with Pinellas County and the Department of the Interior for the return of their landholdings in the former Fort De Soto Military Reservation. In 1941, the entire area was transferred back to the Army (Pinellas County's portion being bought back) for use as a bombing and gunnery range by nearby MacDill Field.

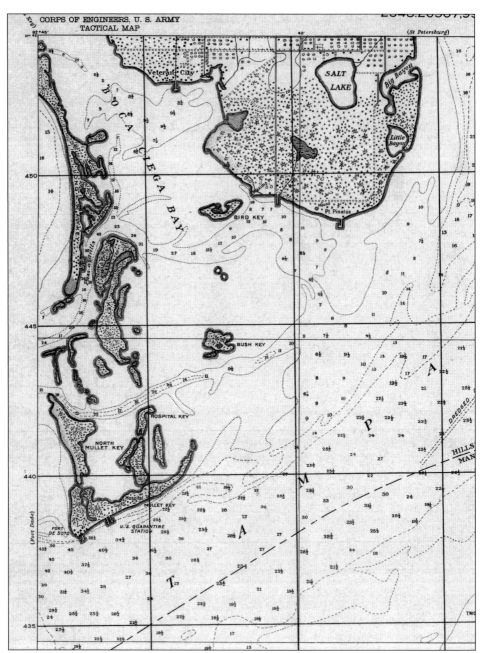

This US Army Corps of Engineers map shows the Boca Ciega Bay area as it was in 1921. Mullet Key, at bottom left, was at that time two separate islands—Mullet Key proper and North Mullet Key. The locations of Fort De Soto (marked by a four-pointed star) and the quarantine station are clearly labeled on the very south of Mullet Key. The location of the quarantine station hospital is labeled to the right of the station's pier. Pine and Cabbage Keys, the two large islands to the north of Hospital Key, are simply labeled "Pine Key" with the word "Key" seen on what is now called Cabbage Key. To the northeast is Pinellas Point, labeled "Pt. Pinelos" on this map. Just to the left of that label, very near the shore, the Pinellas Point Temple Mound is designated with a small circle and the word "mound." (Courtesy of USGS.)

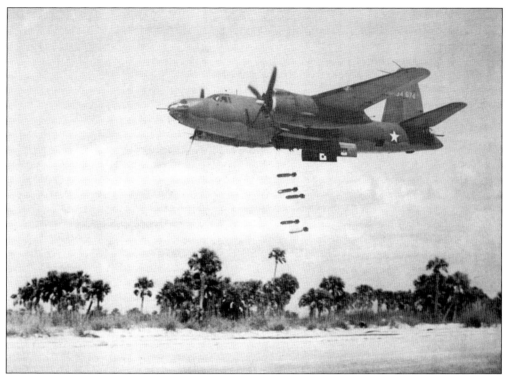

In 1941, it was decided to use Mullet Key as a gunnery and bombing training range for the US Army Air Corps base at MacDill Field, just a few miles away by air across Tampa Bay. Here, a B-26 Marauder is seen coming in at very low altitude to deliver its payload of sand-filled practice bombs. This outstanding photograph freezes the bombs in midair. (Courtesy of the US Army.)

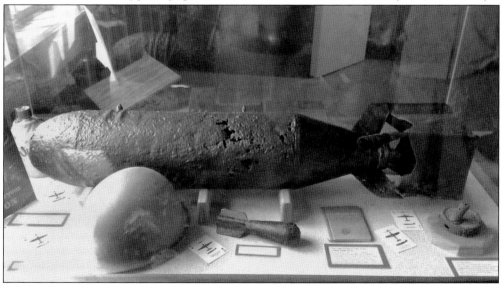

This bomb, similar to the ones in the picture at the top of the page, can be seen at the Quartermaster's Storehouse Museum at Fort De Soto Park. It is one of several unexploded bombs found over the years at the park, including some that were still live and needed to be detonated by ordnance experts. (Photograph by Mike Miller.)

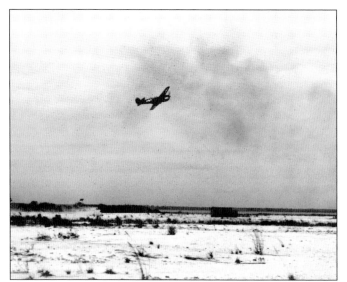

A P-40 Warhawk pulls up after delivering a string of incendiary bombs at the Mullet Key bombing range in February 1945. Dust kicked up from the first bomb is just visible in the sand behind the plane an instant before the bomb ignites. There are still some bomb craters in the area of the Arrowhead picnic grounds. (Courtesy of Alan Shellhorn.)

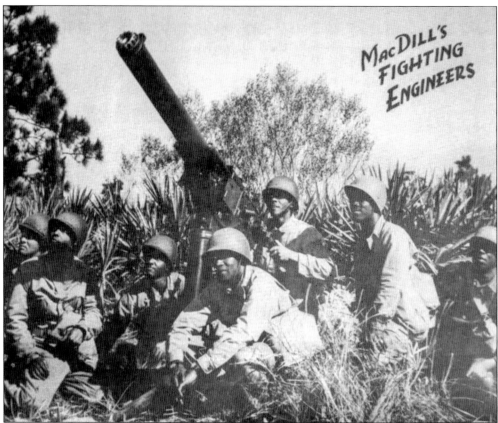

In 1941, Mullet Key was designated as a sub-post of MacDill Field, and work began on the gunnery range and bombing range. A Black unit, Company A of the 810th Engineers, was assigned to organize and largely staff the project. The spring 1943 edition of MacDill's base magazine *Thunder Bird* featured this unit on its pages, including this action shot of the engineers. (Courtesy of the US Army.)

MacDill's *Thunder Bird* was published quarterly throughout World War II with articles featuring aircraft, base units, individuals, military humor, and the occasional very graphic anti-enemy propaganda illustrations. (Courtesy of the US Army.)

Thunder Bird's spring 1943 issue highlighted the Black units serving on Mullet Key. MacDill's brass was very concerned about racism on the base and sought to present Black soldiers as an integral component of the war effort. This *Thunder Bird* feature story exemplifies that effort. (Courtesy of the US Army.)

NEGRO UNITS

Preparing to take battle to the enemy MacDill's Negro troops train diligently.

A Negro soldier has a proud tradition. In all the wars from the Revolution to the present conflict, Negro troops have assumed their full share and acquitted themselves nobly. More than 400,000 Negro soldiers served in World War I. The number serving today is a military secret.

At MacDill Field, whether in Aviation Squadrons, Engineering companies or Ordnance units, the Negro soldier will be found doing his job and doing it exceptionally well. Serious, hard-working and high spirited, he has exhibited on numerous occasions his ability for crack performance on the drill ground or in specialized training work.

MacDill Field is justly proud of its Negro units, for they are not only builders and maintenance experts, they are combat teams that offer a formidable front to any enemy that may oppose them.

At Mullet Key is the MacDill Field bombing and gunnery range, which is maintained by men from the Aviation Squadrons. Many skilled Negro soldiers serve in the checking towers on the bombing range and on the gunnery range where aerial fighters learn their trade.

From one end of the country to another thousands of Negroes are learning to use the tools of modern war. Negro officers, soldiers, doctors, nurses and WAACs, all adding to the distinguished record made by their forebears.

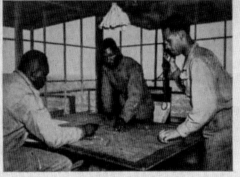

KEEPING SCORE AT THE BOMBING RANGE

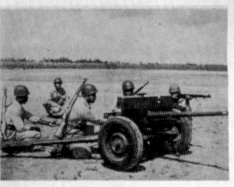

THIS 37MM. GUN CREW PRACTICES MARKSMANSHIP

Page Forty-nine

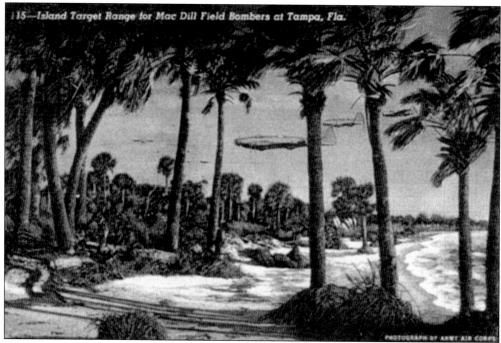

115—Island Target Range for Mac Dill Field Bombers at Tampa, Fla.

PHOTOGRAPH BY ARMY AIR CORPS

This dramatic postcard features MacDill bombers sweeping in over Mullet Key. Note the attribution at bottom right, "Photograph by Army Air Corps." (Courtesy of the Friends of Fort De Soto.)

Thunder Bird magazine would sometimes have features wherein editorial staffers would display their personal photography. To set the record straight, here is the origination of the postcard at the top of the page. S.Sgt. Samuel L. Mase's photograph *Light, Shadow, and Palms at Mullet Key* was pictured in the winter 1944 issue of *Thunder Bird*. (Courtesy of the US Army.)

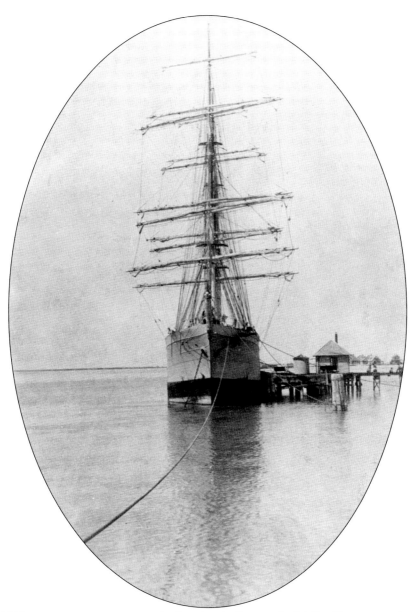

In this 1916 image, a square rigger is discharging ballast at the Mullet Key quarantine station. Once all persons were removed from a ship, several methods, including burning sulphur pots or applying calcium oxide (quick lime) or mercury solutions, were used in an attempt to cleanse the ballast hold and decks. It was unknown until 1900 that yellow fever was transmitted by mosquitos, so those early attempts at disinfection were ineffective. A ship such as this is the subject of a report regarding yellow fever incubation periods from the March 9, 1901, *Medical Record*: "Schooner *R.D. Spear* from New York to Key West, where she lay unloading during the epidemic of 1899. The crew was not allowed ashore, but the captain went ashore every night. She left Key West September 15, 1899, and arrived at Mullet Key quarantine September 19th. Disinfection was completed September 20th, 4 P.M. The captain sickened and had a chill on September 24th at 2 A.M. Incubation not less than three days and ten hours. (D.M. Echemendia, quarantine officer, Tampa Bay quarantine, Florida board of health.)" (Courtesy of HV.)

TREASURY DEPARTMENT

Public Health and Marine-Hospital Service of the United States

PUBLIC HEALTH BULLETIN No. 55

JULY, 1912

A WORD TO SHIP CAPTAINS ABOUT QUARANTINE

AN OPEN LETTER TO SHIP CAPTAINS

BY

L. E. COFER

*Assistant Surgeon General
Chief, Division of Foreign and Insular Quarantine of the Bureau of the Public Health
and Marine-Hospital Service*

Rats carry plague, mosquitoes carry yellow fever
Plague and yellow fever cause quarantine
Quarantine means expense
Ship captains, destroy your rats and mosquitoes, and not only
save your owners money, but save lives

WASHINGTON
GOVERNMENT PRINTING OFFICE
1912

The scourge of infectious diseases, including cholera, malaria, and yellow fever, was a constant fear among mariners, at seaports, and for the general public as a whole. This July 1912 Treasury Department public health bulletin carried a simple message to ship captains: "Rats carry plague, / mosquitos carry yellow fever / Plague and yellow fever cause quarantine / Quarantine means expense / Ship captains, destroy your rats and mosquitos, and not only / save your owners money, but save lives." Yellow fever was sometimes called yellow jack, a slang term thought to be originally used by British sailors after the yellow flag, or "jack," which was required to be raised by ships carrying yellow fever or other infectious diseases on board. The term *quarantine* derives from the Italian phrase *quaranta giorni*, meaning 40 days. In the 14th century, as the bubonic plague raged, this was the amount of time foreign ships had to wait in Venice's harbor before being allowed to dock. (Courtesy of the Government Printing Office.)

In 1798, Pres. John Adams signed into law the Act for the Relief of Sick and Disabled Seamen. This act, creating the Marine Hospital Service, authorized the deduction of 20¢ per month from the wages of seamen for the purpose of funding their medical care as well as building additional hospitals specifically for treating them. Beginning in 1801, the first hospitals fully dedicated to treating mariners were built in Boston; New Orleans; Norfolk, Virginia; Newport, Rhode Island; and Charleston, South Carolina. (Courtesy of the National Library of Medicine.)

The outbreak of a severe yellow fever epidemic, beginning in New Orleans in 1877, led Congress to pass the Quarantine Act and establish the National Board of Health. The Marine Hospital Service took the lead in preventing the spread of infectious diseases, including quarantine efforts. In 1889, the service was organized along military lines, and in 1912, it simply became the Public Health Service. The flag of the service, shown here, is colored yellow with a blue emblem. (Courtesy of the US Public Health Service.)

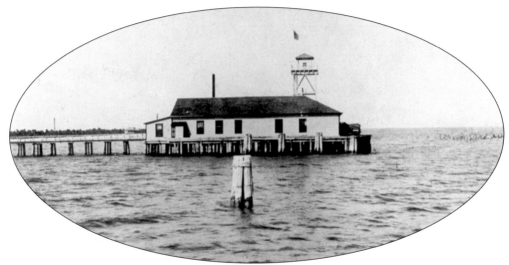

In 1889, the Hillsborough County Board of Health was granted a license to establish a quarantine facility on Mullet Key, then part of that county. The next year, construction began for a wharf and a 200-foot-by-37-foot L-shaped building at its end with the quarantine station opening on April 29, 1891. This building initially was multipurpose, including processing ship personnel and serving as a hospital. Eventually, a separate hospital was built on shore. (Courtesy of HV.)

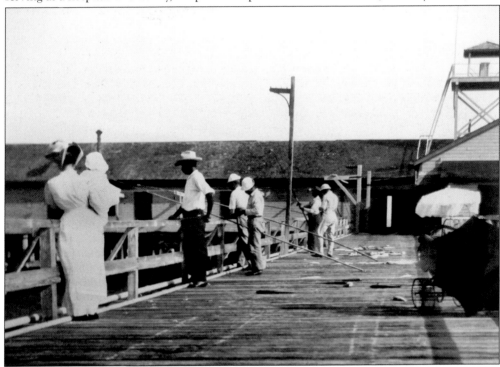

In 1899, jurisdiction of the station was transferred to the Department of the Treasury along with 271 acres of land. In 1900, four buildings from the Marine Hospital Service facility on nearby Egmont Key were dismantled and rebuilt on Mullet Key, where a cottage and sanitary facilities already existed. As can be seen in this c. 1910 photograph, the quarantine station's wharf provided recreation as well as promoting wellness. (Courtesy of HV.)

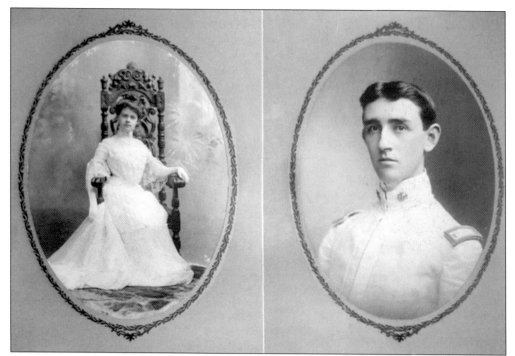

Irva and Holcombe Robertson of Warrenton, Virginia, celebrated their June 1, 1903, marriage by posing for this formal wedding photograph. Holcombe is proudly wearing the uniform of the Public Health and Marine Hospital Services, for which he had received his commission as an assistant surgeon in November of the previous year. He was assigned to the quarantine station on Mullet Key at a salary of $1,600 per annum, around $51,000 today. (Both, courtesy of FDS and Phil Schiro.)

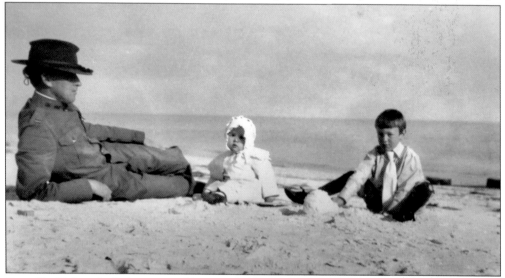

Here, Dr. Holcombe Robertson and his two children take a moment to relax on the beach. Many of the following photographs are of the Robertson family. Others are unidentified individuals who most likely worked and lived at the quarantine station alongside the Robertsons. What they all have in common is finding enjoyment in a beautiful but sometimes very inhospitable place. (Courtesy of FDS and Phil Schiro.)

On March 22, 1893, the fourth annual report of the State Board of Health of Florida included the following report from the state health officer. This report provides an insight into the operation of such a facility at that time. It read: "The Mullet Key Quarantine Station, at the entrance to Tampa Bay, was in active operation from May to November, during which time 240 vessels arrived and were inspected, released or detained for discharge of ballast and disinfection." (Courtesy of FDS and Phil Schiro.)

The health officer's report continues: "8,317 passengers and seamen belonging to these vessels were examined, passed without detention, or kept for observation for a period ranging from five to fifteen days, as provided for in the rules and regulations." (Courtesy of FDS and Phil Schiro.)

The annual report also stated: "The fact of the crew of the Yellow Fever schooner 'Eva B. Douglas' being treated off the Quarantine Station named, and that no case of sickness invaded the Station or was communicated to the State, is congratulatory evidence of the ability of the State Board of Health to manage successfully emergencies of this kind, and should give confidence to the public as to the vigilance of the officials and the means under the control of the Board necessary to accomplish these ends." (Courtesy of HV.)

The health officer's report continues with the following: "The fees collected at the Mullet Key Quarantine Station amounted to $54,474.25 [$1.6 million today] and $4,117.71 was expended in operating the plant. This does not include $9,381.66, the cost of the ballast crib, which is viewed as a permanent investment." (The square-rigged schooner pictured on page 83 was dumping ballast into the Mullet Key crib.) (Courtesy of FDS and Phil Schiro.)

"A physician in charge and six men operated the plant," read the annual health officer's report. "It is a pleasure to testify to the zeal and efficient management of the Station by Dr. D.M. Echemendia, the Medical Sanitary Inspector, who has ever been careful in his attention to the details of the work and conscientious in compelling obedience to the Maritime Regulations of the Board." (Courtesy of FDS and Phil Schiro.)

The health officer's report continued with this: "Experiments were conducted at this Station in the matter of steam disinfection of different classes of clothing and merchandise as well as letters and mail matter. Examination of tables published elsewhere will show the increase in arrivals at this Station during 1892 over 1891." (Courtesy of FDS and Phil Schiro.)

The report also said the following: "It will be appreciated that each year the growth of commercial industry at Port Tampa and Charlotte Harbor and the increase in exports by transportation chartered in foreign infected ports will demand from this Station more and more work and the constant exercise of careful surveillance and supervision over vessels from these ports, especially from the ports of Cuba, so near to us." (Courtesy of FDS and Phil Schiro.)

"The Ballast Crib, mention of which was made in the last annual report as having been ordered built for this Station, was completed in August and has been of great convenience in the discharge of the ballast of those vessels suspicious as to their ports of departure or for continuous service in tropical seas," stated the health officer's report from 1893. (Courtesy of FDS and Phil Schiro.)

The report continues on: "The cost of this crib was $9,381.66. It is constructed of creosoted pine piling, with yellow pine decking and spring fender piling to protect the main structure, with an approach to the shore, on which a tramway is placed to facilitate the discharge of infected or suspicious ballast and the re-ballasting with clean sand ballast from the shore." (Courtesy of FDS and Phil Schiro.)

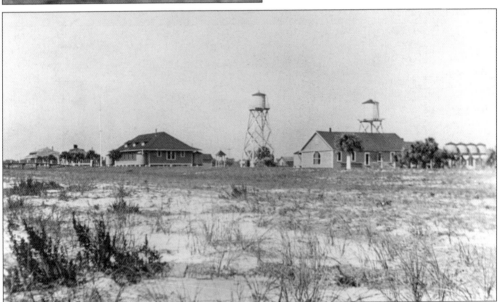

Wrapping up the report, the health officer provides his recommendations: "The suggestions made in last year's report, thought necessary to increase the efficiency of the Board, were carried out in a few particulars. The Boarding Station at Boca Grande Pass has been erected and equipped and the Hospital at the Mullet Key Station has been contracted for. [signed] Dr. Joseph V. Porter." This 1914 image provides a view of the quarantine station from the beach. The pilings of the wharf can be seen at far left; it extends unseen in this photograph out over the water. (Courtesy of HV.)

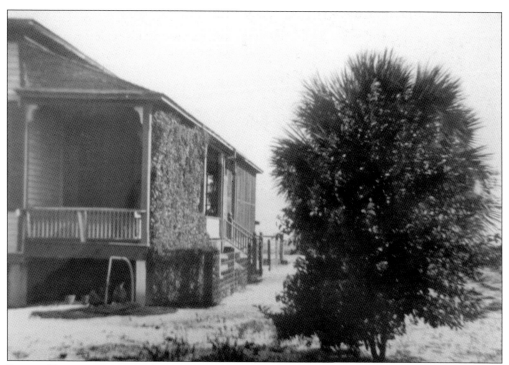

Pictured here is a house at the quarantine station. The ivy covering on the front porch cleverly protects the home from the hot afternoon sun. The date of this image is unknown. (Courtesy of FDS and Phil Schiro.)

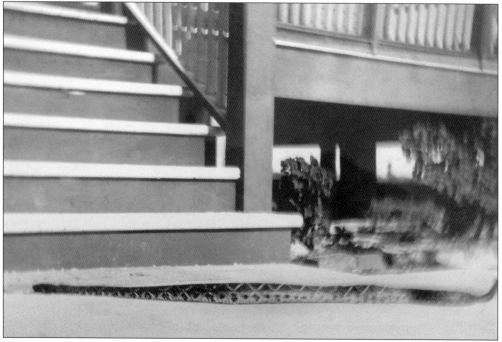

Occasionally, an unwanted visitor would show up at the front steps of quarantine station homes. In this case, it is a rattlesnake. (Courtesy of FDS and Phil Schiro.)

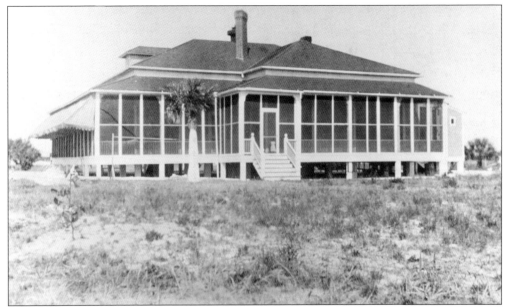

One of the perks of serving as the medical officer in charge at the Mullet Key quarantine station was very nice beachfront living. This 1914 photograph of the house shows the added bonus of a completely screened in wraparound porch. (Courtesy of HV.)

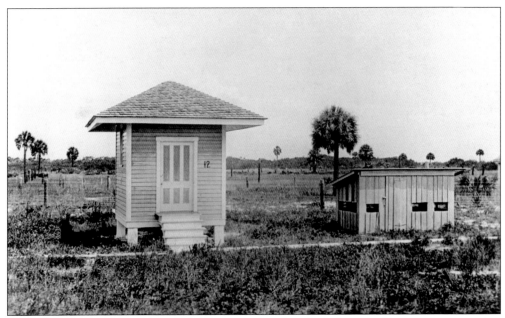

The gashouse, at left next to the chicken coop, produced gas for lighting buildings at the quarantine station. Calcium carbide, when mixed with water, decomposes to produce acetylene gas, which is flammable. An acetylene generator inside the gashouse would create and capture the gas, which was then pressurized and piped out. It was a cheap and effective way to make gas but somewhat dangerous. One has to wonder about the wisdom of placing a chicken coop so close by. (Courtesy of HV.)

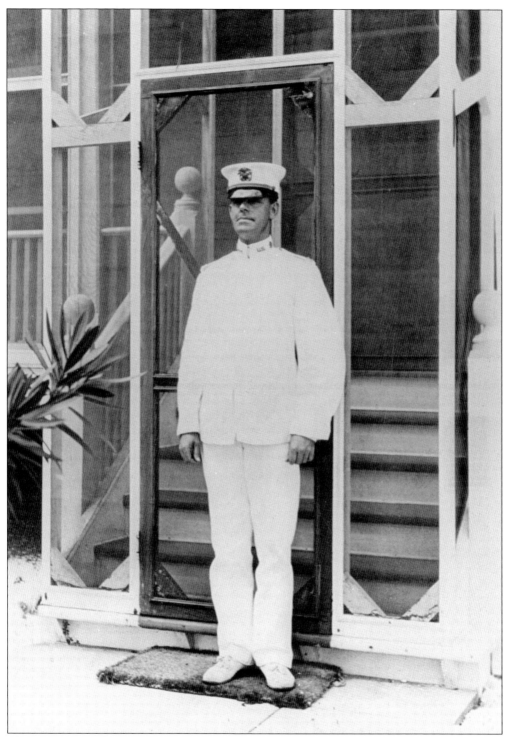

The occupant of the officer in charge house at the time this picture was taken was Dr. Harry J. Warner, who served in that position from 1913 to 1916. He is pictured here proudly wearing the uniform of the US Marine Hospital Service. (Courtesy of HV.)

In this 1915 photograph, Dr. Harry Warner looks much more comfortable and relaxed as he enjoys nature for a few moments. (Courtesy of HV.)

An unidentified medical officer takes a breather on a Mullet Key beach after what looks to have been a very busy day at the office. (Courtesy of HV.)

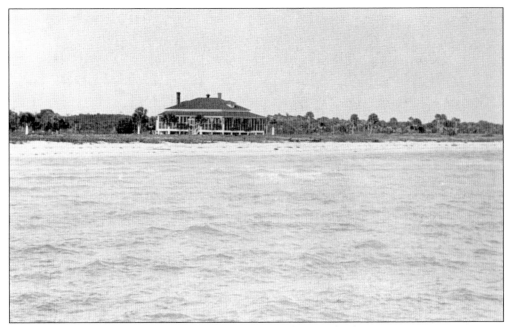

The view from the water of the residence of the medical officer in charge presents a very enticing scene. (Courtesy of HV.)

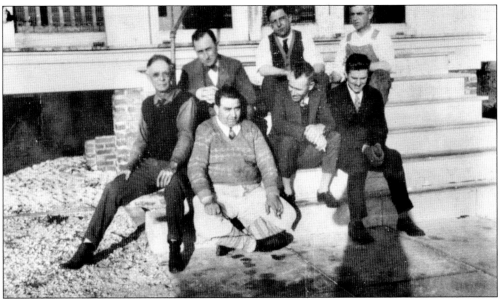

Dr. Percy Ahrons, far left, and several quarantine station staffers relax after a long day's work in the 1920s. Dr. Ahrons was part of the Public Health Service for a total of 28 years. He served as the medical officer in charge on Mullet Key for eight years beginning in 1924. In addition to American ports, Dr. Ahrons also served the government in Mexico and South America. (Courtesy of HV.)

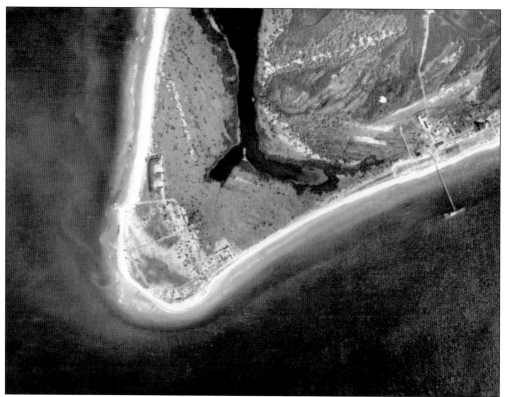

In this c. 1940s aerial image, the location of the Mullet Key quarantine station (marked by the wharf at right) with respect to the remains of Fort De Soto (on the point of land at left) is quite clear. Battery Laidley is visible near the shore at the upper edge of the fort grounds. (Courtesy of Alan Shellhorn.)

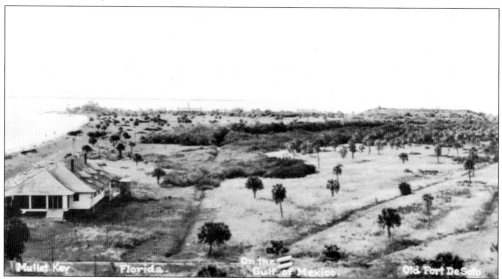

The vantage point of this vintage postcard is from the water tower at the quarantine station. The building on the immediate left is a station building, while Battery Laidley rises above the landscape at far right. (Courtesy of Alan Shellhorn.)

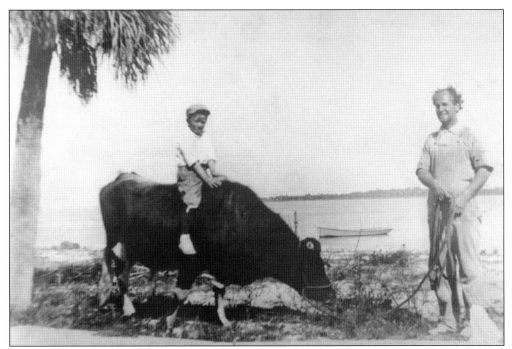

On Cabbage Key, just a couple of miles north of busy Mullet Key with its pestilence, soldiers, mortar blasts, and bombing runs, lived the Dent family. Around 1900, Willis Dent and his two sons, Noah and Silas, left Georgia to settle in Pass-a-Grille on Long Key. After a few years, they homesteaded on close-by Cabbage Key. The Dents brought in a herd of dairy cows, one of which is seen here with Silas and an unidentified young boy in 1918. (Courtesy of GBM and Toni Walsh.)

Cabbage Key, much transformed since this image was taken, is now a major part of Tierra Verde and the gateway to Fort De Soto Park. Although the dairy farm turned out to be unsuccessful, it is clear from this undated photograph that Silas Dent cared very much for his cattle. The family eventually sold their Cabbage Key holdings. Dent tried living in Largo for a while, but eventually, the lure of the island, along with an arrangement with the new landowners, brought him back for good. (Courtesy of GBM and Toni Walsh.)

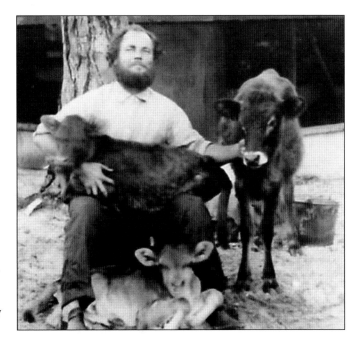

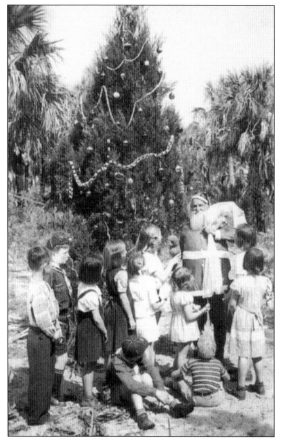

Silas Dent lived alone on Cabbage Key in his thatched hut but welcomed visitors and became quite a local celebrity, so much so that the October 18, 1948, issue of *Life* magazine featured an article about Dent entitled "Happy Hermit of Cabbage Key—Silas Dent." (Courtesy of GBM and Toni Walsh.)

For much of the 1930s and 1940s, Silas, with his white beard, would dress up as Santa and paddle over to Pass-a-Grille during the Christmas season. Tucked away in his rowboat would be candy and gifts for the town's children. It is clear from this late-1940s photograph that a good time is being had by all. Silas Dent passed away in 1952, but his legend and memory endure. (Courtesy of GBM and Toni Walsh.)

Five

THE PARK

"Like San Francisco's Treasure Island"
"Park Board Studies Development of Mullet Key as Spectacle Site"

—*St. Petersburg Times*, February 12, 1954

"Historic Fort Newest Area Attraction"
"Gun Emplacements Remain on Mullet Key; Now Accessible to Visitors by Bayway"

—*Tampa Tribune*, March 17, 1963

"18,000 See Dedication of Fort De Soto Park"
"State's Newest Playground On White Gulf Beach Sands"

—*Tampa Tribune*, May 12, 1963

Henry Fonda brought soil from Wyoming, the setting of his soon to be released film *Spencer's Mountain*, Guy Lombardo brought his Royal Canadians and his racing boat, and Dick Pope brought his Cypress Gardens water ski show to the grand opening of Fort De Soto Park on May 11, 1963.

Like the grandiose plans headlined in the *St. Petersburg Times* (now the *Tampa Bay Times*) seen above, more spectacles were promised on that day. Dick Pope Sr., founder of Cypress Gardens, the famed theme park in Winter Haven, outlined his plans for a multimillion-dollar attraction. In a May 12, 1963, article about Fort De Soto's opening, the *St. Petersburg Times* gushed: "Showman's Square—$2,031,000 marine attraction and family entertainer which can be Florida's greatest facility of its kind seems all but assured for Ft. De Soto Park on Mullet Key."

Fortunately for the 2.7 million visitors who visit Fort De Soto Park each year, this attraction never got off the ground. Instead, in addition to a remarkable Spanish-American War time capsule, visitors get to enjoy nature, boating, camping, fishing, and some of the best beaches in America. But for all that to happen, a better way than by boat had to be found to get to Mullet Key.

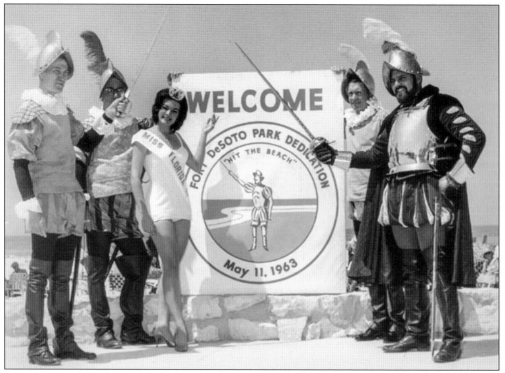

Although the park had been open for several months, May 11, 1963, was the day chosen for Fort De Soto Park's official grand opening. A total of 18,000 people showed up on the perfect 82-degree Saturday to view the park's marvelous new features and upgrades. In this slightly different grand opening photograph, Miss Florida, Gloria Brody of Jacksonville, is joined by the Bradenton Conquistadores, led by Hernando de Soto (Edwin Silver), far right. (Courtesy of FDS and Phil Schiro.)

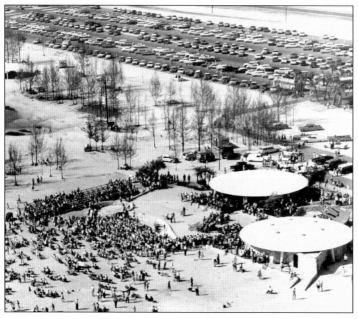

The highlight of this image of the grand opening is the space age/mid-century modern architecture of the park's new buildings. The backdrop for the celebration is the snack bar pavilion, where Guy Lombardo and his orchestra are waiting to perform as one of the honored guests speaks at the podium in front. Lombardo was a champion racing boat driver, and one of his hydroplanes can be seen displayed at far right behind the bathhouse. (Courtesy of HV.)

As part of the opening ceremonies, soil from Spain, the birthplace of Hernando de Soto; from the beaches of Fort De Soto; and from Wyoming, where Henry Fonda, left, had just finished shooting *Spencer's Mountain*, were mixed together in a commemorative silver bowl. Beaming proudly behind the bowl is Pinellas County commissioner Buddy Freeze. (Courtesy of HV.)

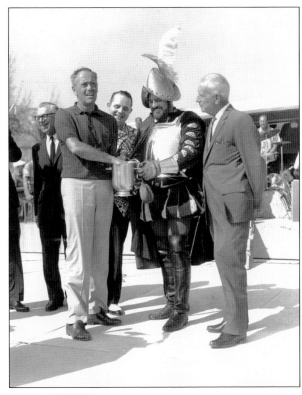

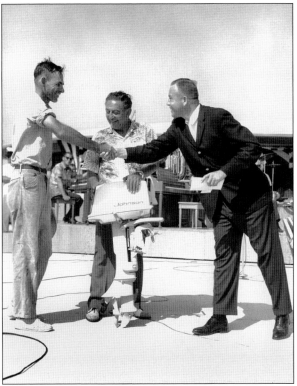

Emcee Raleigh Greene extends congratulations as Guy Lombardo presents an outboard motor prize to Rex Cole Jr., winner of the Tarpon Rodeo fishing competition that was part of the day's fun. A Miss Fort De Soto contest was also held. All the festivities were centered around the park's North Beach. (Courtesy of HV.)

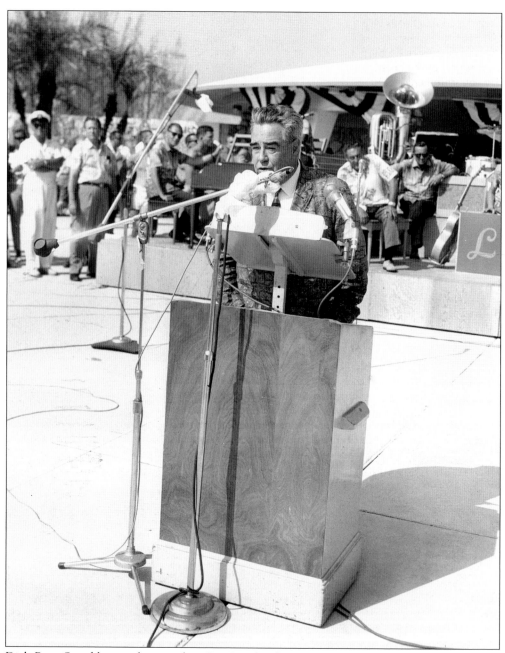

Dick Pope Sr. addresses the crowd as Guy Lombardo and the Royal Canadians look on. The *Orlando Sentinel*'s headline for its January 29, 1988, obituary of Pope read: "Dick Pope Sr Dies, Put Florida On Map." The story goes on to say that he was "the father of modern Florida's tourism and a man hailed as its greatest and most flamboyant salesman." His signature accomplishment was Cypress Gardens, which opened in 1936 as a botanical garden on 16 acres of former swampland at Winter Haven in Polk County. An excellent water skier, in 1928 Pope became the first person to successfully perform a platform jump on water skis. In 1958, he authored *Water Skiing*, a how-to guide published by Prentice Hall. Eventually, Cypress Gardens grew to 200 acres, and its water ski shows became a staple and a worldwide trademark of the park. (Courtesy of HV.)

Dick Pope brought his Cypress Gardens water ski show to the waters off Fort De Soto Park as part of the opening day entertainment. Pope himself designed many of the acrobatic routines for his Cypress Garden shows, such as these performed here. (The photographs here and below may be publicity images provided to the local press by Cypress Gardens.) (Courtesy of HV.)

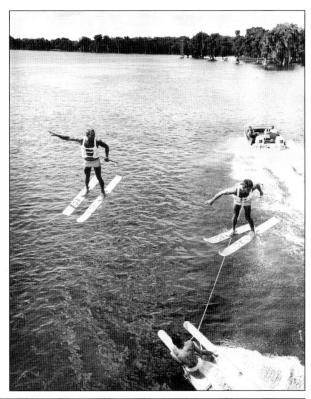

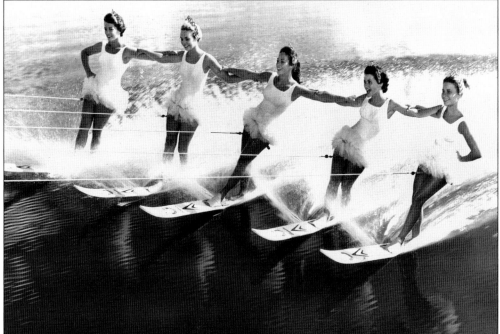

Here, precision skiers from Cypress Gardens make it look easy. Pope's son, Dick Pope Jr., was also an outstanding water skier. He was one of the first persons to water ski barefoot, and both he and his father were inductees into the Water Skiing Hall of Fame. (Courtesy of HV.)

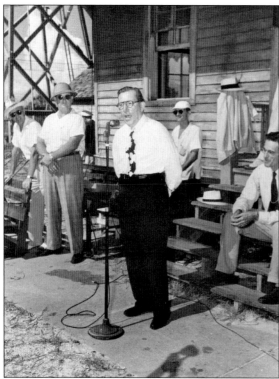

There were no movie stars, bandleaders, or beauty queens present when Florida senator Claude Pepper spoke at the dedication of the first incarnation of Fort De Soto Park on September 8, 1948. Earlier that year, with the military no longer having a need for Mullet Key, Pepper, along with fellow Florida senator Spessard Holland, sponsored legislation authorizing the conveyance of the property to Pinellas County for $20,000, about $220,000 today. (Courtesy of Alan Shellhorn.)

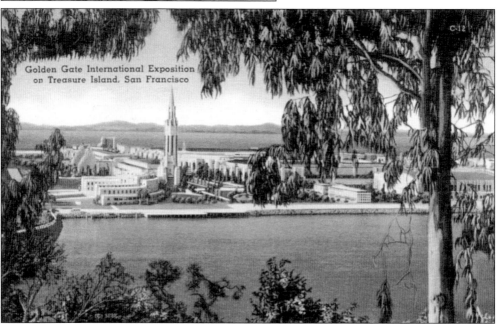

If it was up to Pinellas Parks Commission chairman Warren H. Pierce, Fort De Soto Park might look like this today. At the first park commission board meeting of 1954, Pierce suggested consulting with "a big scale showman like John Ringling North (Ringling circus president) to create a wonderland on Mullet Key" similar to San Francisco's 1939 Golden Gate International Exposition on Treasure Island, shown here. Fortunately, wiser heads prevailed.

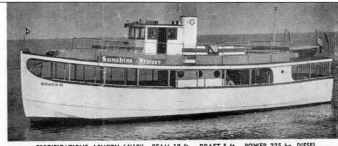

The RANGER III

High, Erect and Proudly she flys the burgee of her owner—a white star of 5 points on a triangular red pennant.

The **RANGER III** was built in Toledo, Ohio by its owner and operator Capt. Geo. B. McElhaney. She cleared Toledo on her maiden trip headed into Lake Erie for Detroit and the Lakes St. Clair and Huron, thru the Straits of Mackinaw into Lake Michigan and the long trip south to Chicago thru the Illinois and Mississippi Rivers to New Orleans and across the gulf to St. Petersburg— a distance of 3500 miles. Upon arrival at her destination she was equipped with all safety devices recommended by the Dept. of Marine Inspection. This Boat is never crowded—we limit our passengers to one hundred although we have 140 seats on two decks which permits the utmost freedom of movement—no sitting in cramped positions during the cruise.

SPECIFICATIONS: LENGTH 64'10" - BEAM 18 ft. - DRAFT 5 ft. - POWER 225 hp. DIESEL

PHONE 74-6922 & 72-8365

Although there was an airstrip on Mullet Key, the only practical way to bring tourists over from the mainland was by boat. Enter George H. McElhaney, a boilermaker from Lima, Ohio, with experience in both railroads and boats. He had the *Ranger III* built in Toledo and then guided it on the 3,500-mile journey through the Great Lakes, down the Mississippi River, and across the Gulf of Mexico to St. Petersburg. (Courtesy of Alan Shellhorn.)

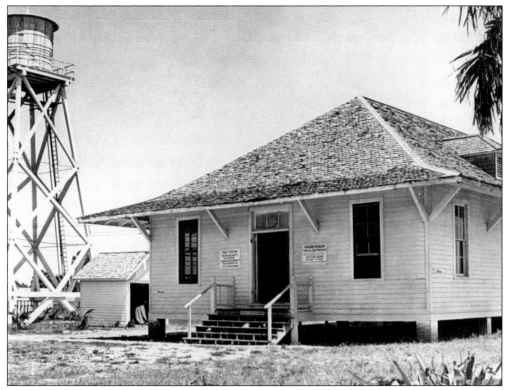

Stepping off the *Ranger III* in the early 1950s, the first building people encountered on Mullet Key was the Marine Museum, curated by Marvin Wass, a marine biologist who did postgraduate work at Florida State University. The museum boasted 3,500 live and mounted exhibits largely from the waters surrounding Mullet Key. Originally, this building was part of the Mullet Key quarantine station. (Courtesy of HV.)

107

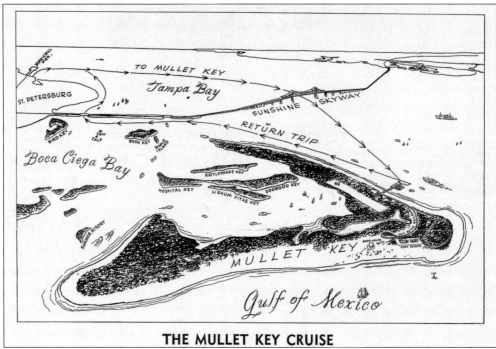

THE MULLET KEY CRUISE

Initially, McElhaney's *Ranger III* was a cruise boat operating out of Pass-a-Grille, but eventually, he was taking tourists from St. Petersburg to Mullet Key. This image is from a 1950s *Ranger III* brochure outlining the excursion from downtown St. Petersburg and back, including a stop at Mullet Key. Other boats provided cruises to Mullet Key, including the *Miss Alabama*, sailing from Pass-a-Grille. (Courtesy of Alan Shellhorn.)

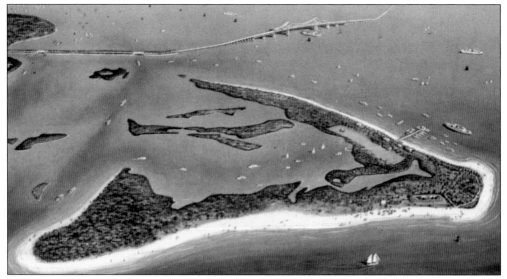

The original version of the map at the top of this page is this 1954 postcard designed by Edward G. Smith and Charles A. Lenz. According to an October 1977 *St. Petersburg Times* obituary, Charles A. Lenz and Associates was the largest insurance agency in the Southeast, employing over 600 brokers. The article goes on to say that he was "the first developer of Mullet Key . . . installing a concession stand, sightseeing railroad and bait stands."

In 1954, as the Pinellas County park board pondered ways to get more people to visit Mullet Key, George McElhaney commented, "There's too many people who claim there's nothing out there but mosquitos." He had requested of the board permission to establish a scenic railway, which would easily allow tourists to visit the old fort and the beaches on the island. (Courtesy of Bill DeYoung, *St. Pete Catalyst*.)

Scenic Jungle Tour on Mullet Key, Florida

George McElhaney's vision came to pass later in 1954 when the Fort De Soto & Gulf Beaches Railroad opened for business. He built his rolling stock by hand (including using Willys Jeep engines for his locomotives) and laid a total of 5,000 feet of 18-inch-gauge rail. The train became so successful that a second line, pictured in the two images on this page, was added a few years later, running from the North Beach to the fort.

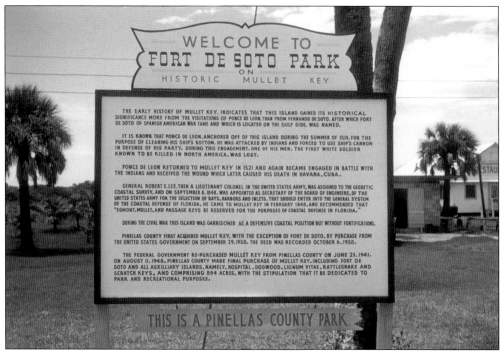

In the mid-1950s, an unidentified group chronicled its day at Fort De Soto Park. The group started off by taking a picture of the welcome sign, which greeted everyone coming off the dock. Anderson's Restaurant can be seen in the background to the right. In 1954, a *New York Times* travel correspondent wrote of Anderson's: "It's where this visitor had his best apple pie since New England." (Courtesy of Steve Fasnacht, ©flic.kr/electrospark.)

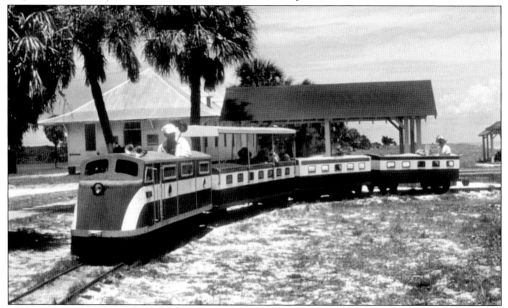

Here, a man in the last car of McElhaney's original train (wearing a captain's cap) waits for his fellow travelers to join him for the trip after taking his picture. The building in the background is from the old Mullet Key quarantine station. (Courtesy of Steve Fasnacht, ©flic.kr/electrospark.)

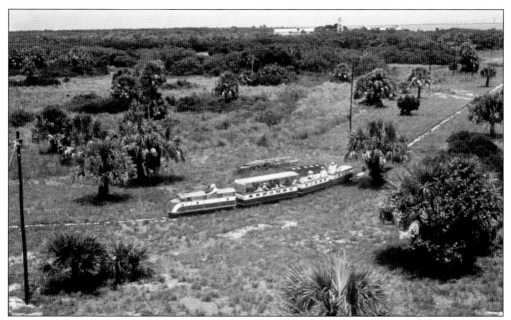

Visitors enjoy the view from the top of Battery Laidley as the next train approaches. This view gives a great perspective as to how close the former quarantine station (marked by the water tower) was to Fort De Soto. In the background, in the far upper right, can be seen the original Sunshine Skyway Bridge, still with only a single span. (Courtesy of Steve Fasnacht, ©flic.kr/electrospark.)

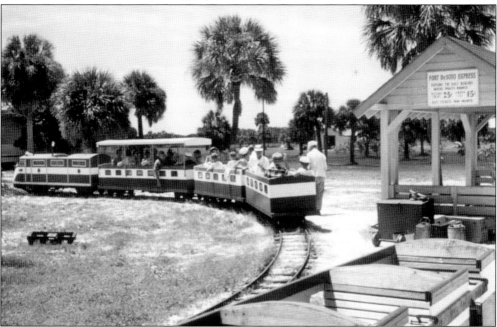

Their round-trip complete, the train's conductor begins off-loading passengers. The man with the captain's cap managed to get his favorite seat back for the return trip. The success of George McElhaney's railroad was marked with a December 1960 contest for its 100,000th rider. A lifetime railroad pass, lunch for the family, and $10 pocket money (around $100 today) was the prize for the lucky winner. (Courtesy of Steve Fasnacht, ©flic.kr/electrospark.)

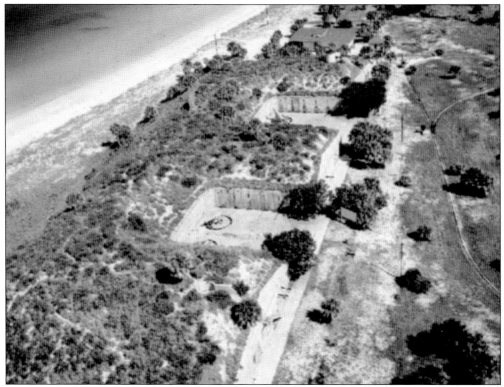

This 1956 photograph shows the scene at the fort terminus of the original Fort De Soto & Gulf Beaches Railroad. From here, passengers could disembark for the bathhouse (with the rectangular roof) or Battery Laidley. (Courtesy of USF Digital Collections.)

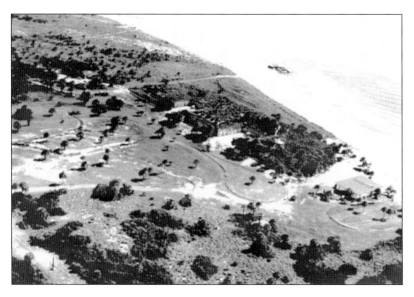

The fort termini of both the original railroad and Jungle Tour railroad from North Beach are seen here near the bathhouse. The ruins of Battery Bigelow lie just offshore. (Courtesy of the US Fish and Wildlife Service.)

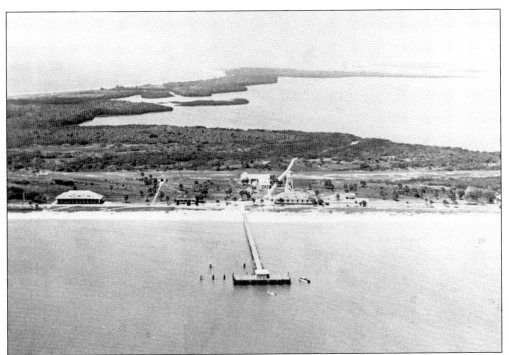

In this c. 1955 image, the old dock and Anderson's Restaurant (to the left of the water tower) are still going strong. The only existing road skirts just to the right of Anderson's. (Courtesy of HV.)

In the same view five years later, Anderson's is gone, the old dock has been replaced by a new and improved one, and there is a brand new paved road running parallel to the beach. The road, which runs the entire length of Mullet Key, is named Anderson Boulevard. (Courtesy of HV.)

In August 1954, another group, this time the Thompson family, spent the day at Fort De Soto Park. These photographs recorded snippets of that summer's day activities. They began their day by boarding the *Miss Alabama* at Pass-a-Grille for their journey to Mullet Key. Here, mom Marguerite and her son Tommy wait for their adventure to begin. (Courtesy of FM.)

From left to right, grandmother, Marguerite, and Tommy settle into their train car and await the trip to the fort as dad William takes the snapshot. (Courtesy of FM.)

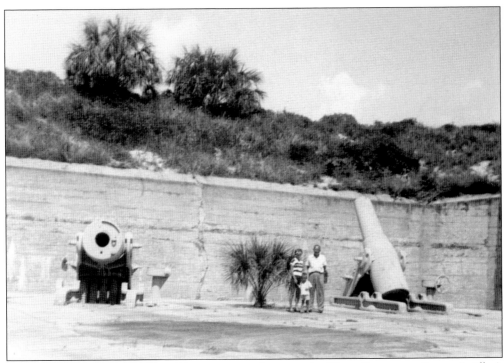

Marguerite, Tommy, and William Thompson pose between the Watervliet guns at Battery Laidley's mortar pit A while grandmother handles the camera duties. (Courtesy of FM.)

Back at the railroad station, Marguerite, Tommy, and grandmother (with dad William behind the lens) pose next to the train as they wait to board the *Miss Alabama* for the trip back to Pass-a-Grille. These four photographs were donated to the wonderful Florida Memory website. (Courtesy of FM.)

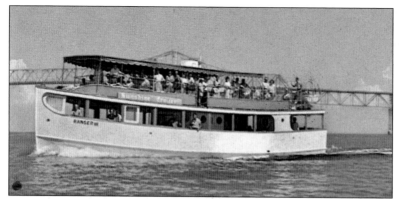

The *Ranger III*, now outfitted with an upper deck, passes by the original Sunshine Skyway Bridge on its way to Mullet Key. (Courtesy of Alan Shellhorn.)

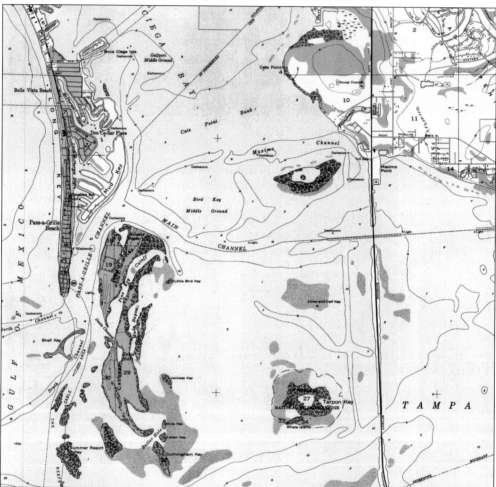

In the mid-1950s, Fort De Soto Park was seeing visitors numbering in the thousands each year. With Mullet Key and the other nearby islands accessible only by boat, road access was essential for the park to reach its potential. Around this time, Dr. Bradley "Doc" Waldron convinced the State of Florida to sell him Pine and Cabbage Keys (seen at the bottom left on this 1956 map) and surrounding areas of submerged sand. He then formed a partnership with Detroit-based developers Hyman and Irving Green. (Courtesy of USGS.)

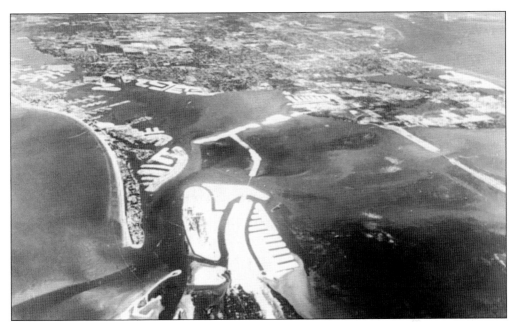

The Waldron-Green partnership named its new development Tierra Verde, Spanish for "green land." Hyman Green persuaded the state to add a spur heading south through Tierra Verde from the east-west Pinellas Bayway by offering land on which the road could be built. That arrangement facilitated Pinellas County's goal of a road link to Fort De Soto Park. This photograph shows the drastic changes to Pine and Cabbage Keys as this mammoth project moved forward in the early 1960s. (Courtesy of GBM and Toni Walsh.)

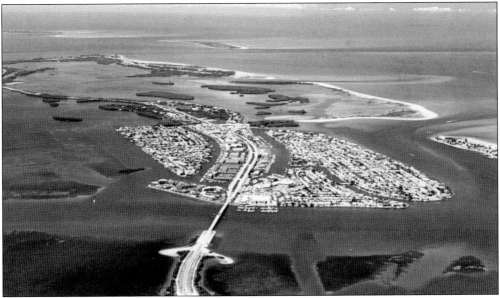

By the mid-1960s, all the fill and seawall work was complete in Tierra Verde. In this recent image, looking south rather than north as in the previous image, Tierra Verde is almost fully developed. The Pinellas Bayway can be seen meandering off to the left toward Fort De Soto Park, where it ends. The Tocobaga Mound historical marker on the Bayway is just past the last major neighborhood. (Courtesy of tierraverderealestateblog.com.)

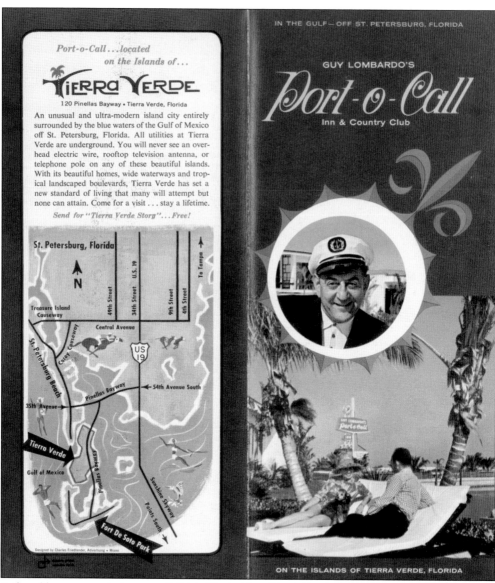

Before (the apparently immortal) Dick Clark, New Year's Eve belonged to Guy Lombardo. His Royal Canadians' version of "Auld Lang Syne" was what everyone played on New Year's Eve. In 1961, Connecticut developers Louis and Fred Berlanti bought into the Tierra Verde project. Meanwhile, Lombardo wanted to establish a fabulous resort on Florida's Gulf Coast. The trio partnered in Guy Lombardo's Port-o-Call, a high-end resort with a sophisticated nightclub located on Tierra Verde. This 1963 promotional brochure was designed by Charles Friedlander Advertising of Miami. In the bottom photograph on the previous page, the former location of the Port-o-Call resort is marked by the large rectangular building just to the right of the bridge landing. (Courtesy of Tampa Bay History Center, Touchton Map Library.)

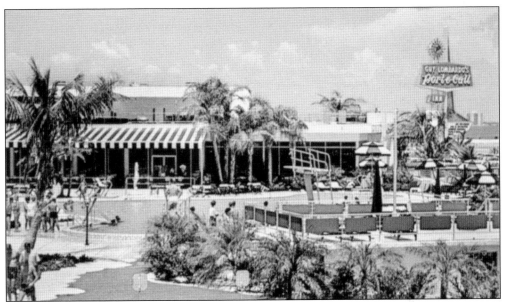

Mel Torme, Lionel Hampton, Rosemary Clooney, Steve Allen, Patti Page, Milton Berle, and many, many other big stars played at Guy Lombardo's Port-o-Call, seen in the postcard above. The Berlantis hoped that such associations and publicity would spur interest in Tierra Verde, while Lombardo would travel the country putting on shows, his buses carrying signs touting his Florida resort.

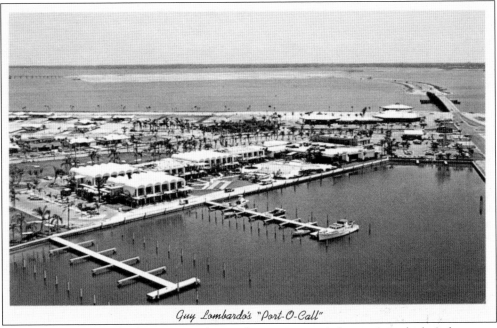

Guy Lombardo's "Port-O-Call"

Port-o-Call's futuristic/mid-century modern architecture provided an exciting look to the resort. Unfortunately, the resort proved unprofitable, and Guy Lombardo bowed out as an owner. A bank took over. Eventually Port-o-Call was demolished and replaced by a marina. The sandbar in the background is now the Isla Del Sol development with over 3,000 housing units, a golf course, and nine tennis courts. This postcard was sent by two snowbirds to friends in Indiana in February 1965.

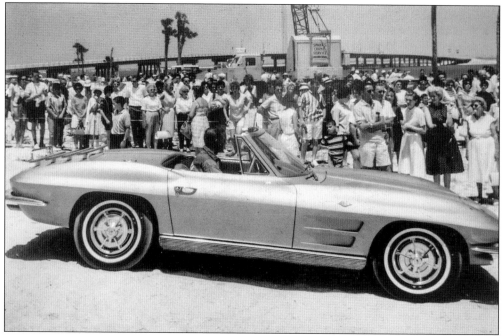

Guy Lombardo's show business connections ensured further publicity for Port-o-Call. In May 1963, the popular television show *Route 66* aired an episode set on Tierra Verde. Given Lombardo's boat racing credentials—he was a champion hydroplane driver—the theme of the show, entitled "So What Do You Do In March?," was racing and ended with a thrilling boat race. The show's two wandering heroes were lucky enough to journey America in this beautiful 1963 Corvette. (Courtesy of jeffnoa and rich5962, corvetteforum.com.)

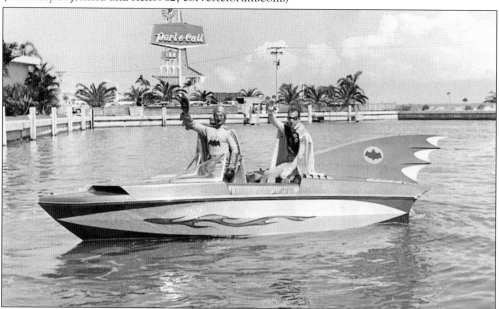

More cross promotion is exemplified here with the "Batboat," from television's *Batman* series, cruising the Port-o-Call harbor. Apparently, Adam West and Burt Ward were unavailable for this 1966 publicity shot. (Courtesy of Darren Nemeth.)

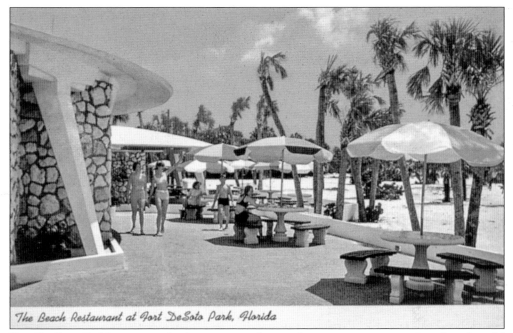

Fort De Soto Park's space age/mid-century modern architecture is epitomized in this cheerful postcard from the 1960s with white sands as a backdrop. This design was consistent in every building throughout the park, including headquarters, service buildings, picnic shelters, and restrooms. (Courtesy of Phil Shiro.)

In this similar view from the present, the genius of the park's architecture is apparent as these buildings look as fresh and modern now as they did 60 years ago.

These two men seem to have the place to themselves on this pleasant sweater-weather day in the early 1960s.

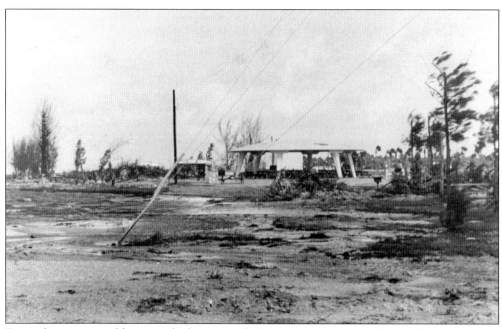

Even a hurricane could not touch the picnic shelter at Fort De Soto Park's North Beach in the 1960s. (Courtesy of HV.)

South Dakota leads off this section of the Corridor of State Flags, which graced the walkway outside of Battery Laidley in the 1960s. Florida residents might be surprised to learn that, at that time, South Dakota's state flag carried the slogan "The Sunshine State" under its state seal. In 1992, South Dakota changed its slogan to "The Mount Rushmore State," much to the relief of all concerned.

In 1968, George McElhaney's hand-built rolling stock was replaced by a more fanciful C.P. Huntington train set manufactured by Chase Rides of Wichita, Kansas. This new train was capable of hauling 100 passengers and could travel at speeds of up to 12 miles per hour. Although made to look like a steam engine, the train was actually powered by a four-cylinder gasoline motor.

Chase Rides products include carousels, roller coasters, and carnival rides such as the Zipper. The park's railroad service was discontinued in the early 1970s. Sharp-eyed readers will note that in both this and the postcard at the top of the page, the same woman and two children are still waiting to board the train. Visible in the background is the Corridor of State Flags. (Courtesy of Bill DeYoung, *St. Pete Catalyst*.)

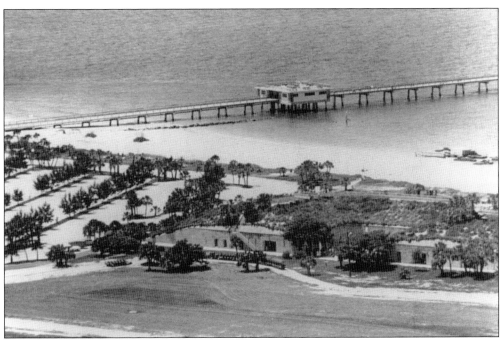

In this 1965 image, the new 1,000-foot pier, the ruins of Battery Bigelow on the beach to the right, and Battery Laidley at center with the park railroad posing in front it are all visible. (Courtesy of HV.)

Looking almost like a scene from *Lawrence of Arabia* but promising a much more pleasant rail journey, the C.P. Huntington train traverses the park's beautiful white sands heading to the fort. (Courtesy of HV.)

The caption on the back of this 1970s postcard says it all: "It's feeding time for the seagulls on the east beach of Ft. De Soto Park. The Sunshine Skyway Bridge can be seen in the background. This is but one section of beautiful white sandy beaches that stretches for miles on scenic Ft. De Soto Park. A visit to this historical area is a must for everyone." (Courtesy of FM.)

This recent photograph was taken not far from the postcard at the top of the page. The Bob Graham Sunshine Skyway Bridge, which replaced the original Sunshine Skyway Bridge in 1987, provides the backdrop for another beautiful day at the park. A visit to this area truly is a must for everyone.

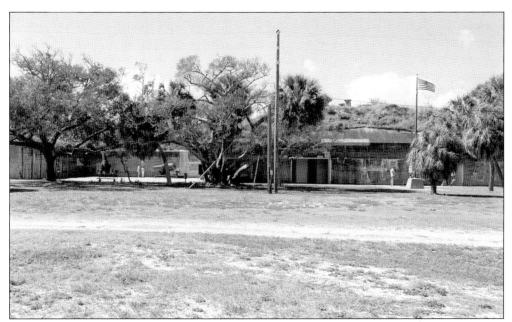

There is a subtle yet meaningful difference about the stars and stripes seen here flying high in front of Battery Laidley. This star field contains 45 stars, representing the flag that would have flown over Fort De Soto during the Spanish-American War era.

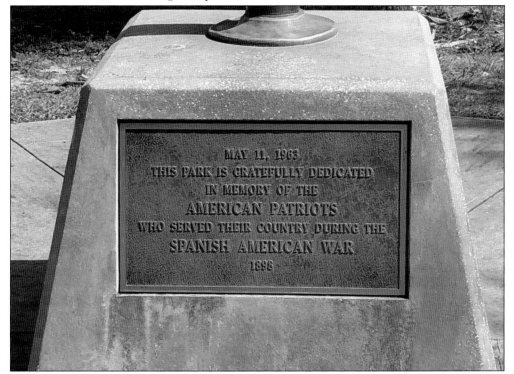

MAY 11, 1963
THIS PARK IS GRATEFULLY DEDICATED
IN MEMORY OF THE
AMERICAN PATRIOTS
WHO SERVED THEIR COUNTRY DURING THE
SPANISH AMERICAN WAR
1898

The plaque on the base of the flagpole is a reminder that, despite the wonderful playground that exists here today, first and foremost the creation of the park was in honor of the soldiers who proudly served their country here at Fort De Soto.

DISCOVER THOUSANDS OF LOCAL HISTORY BOOKS FEATURING MILLIONS OF VINTAGE IMAGES

Arcadia Publishing, the leading local history publisher in the United States, is committed to making history accessible and meaningful through publishing books that celebrate and preserve the heritage of America's people and places.

Find more books like this at
www.arcadiapublishing.com

Search for your hometown history, your old stomping grounds, and even your favorite sports team.